Postcard History Series

St. Cloud

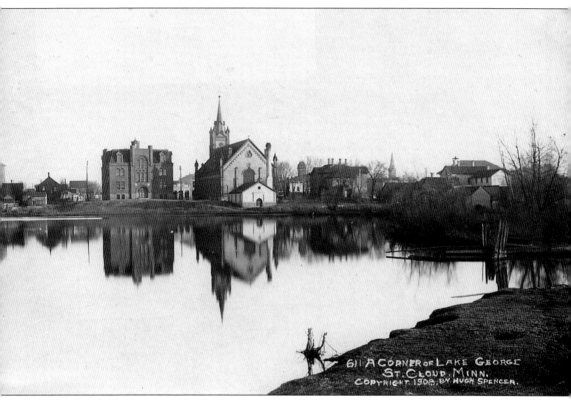

This Real Photo postcard of Lake George, taken in 1908 by Hugh Spencer, is a beautiful example of a vintage postcard. The photographer has found the right time of day for capturing the reflections of many town landmarks that are now long gone, including the unique water tower, the German Catholic church, the courthouse, and the lofty spire of the cathedral, as well as the huge lake itself. (Author's collection.)

ON THE FRONT COVER: This is the parade line-up on Decoration Day 1910, and these 13 young women, daughters of members of the Women's Relief Corps of the Grand Army of the Republic James McKelvey Post 134, have been chosen to carry the flag. Their parade's purpose was to promote patriotism and perpetuate the Memorial Day parade and celebration. (Author's collection.)

ON THE BACK COVER: First lit on May 16, 1923, this sign was given to the city by the American Automobile Club. It sat at the intersection of East St. Germain Street and Jefferson Highway, now Lincoln Avenue. (Author's collection.)

POSTCARD HISTORY SERIES

St. Cloud

Harold Zosel

Copyright © 2010 by Harold Zosel
ISBN 978-0-7385-7787-6

Published by Arcadia Publishing
Charleston SC, Chicago IL, Portsmouth NH, San Francisco CA

Printed in the United States of America

Library of Congress Control Number: 2009942138

For all general information contact Arcadia Publishing at:
Telephone 843-853-2070
Fax 843-853-0044
E-mail sales@arcadiapublishing.com
For customer service and orders:
Toll-Free 1-888-313-2665

Visit us on the Internet at www.arcadiapublishing.com

This book is dedicated to my wife Mary, daughter Katie, son Sam, and to O. O. W., wherever you are.

Contents

Acknowledgments 6

Introduction 7

1. Industry and Transportation 9

2. Main Street and Public Buildings 37

3. People and Occasions 97

Acknowledgments

This book could not have come into being without the help of many people. First and foremost, I want to thank the photographers who created the images resulting in the book's postcards, including Hugh Spencer, Frank King, Bloom Brothers, W. E. G., D. and S., and the many others who remain unknown.

I also want to thank the postcard companies that created the postcards we collect today, including Bloom Brothers, Co-Mo Inc., Crescent, Curt Teich, E. C. Kropp, the Rotograph Company, and numerous other unknown companies.

I would also like to thank the postcard dealers who searched the country and found many cards, and my many friends who shared cards from family accumulations. A special thanks goes to the super sleuths at the research department of the Stearns History Museum; archivists John Decker, Robert Lommel, and the newest archivist, Sara Warmka, all generously helped locating files, maps, microfilm, and other items and in searching for answers to my many (sometimes dumb) questions about the subjects of the postcards. How fortunate we are to have this facility in St. Cloud with almost unlimited information about the past.

All postcards appear courtesy of the author.

Introduction

St. Cloud began as a multiple birth. At approximately the same time (1853–1855), three different men saw possibilities of a town on the west bank of the Mississippi River.

Gen. Sylvanus P. Lowry, a Protestant, Southern Democrat, and slaveholder, was a fur trader at nearby Watab. Lowry claimed the land from Fourth Street North, the northern ravine, all the way to the Sauk Rapids Bridge. The "Upper Town" part of the combination was originally named Acadia, but later it was plotted as Lowry's Addition.

The second founder, George Fuller Brott, was a professional town site promoter who persuaded other Protestant Republican Easterners to come to "Lower Town," the area between the southern ravine, flowing from Lake George to the Mississippi, and the present-day children's home.

The third founder was a Protestant Yankee, John L. Wilson, who was here to erect a sawmill in Sauk Rapids on the east side of the Mississippi. Wilson persuaded German Roman Catholic immigrants headed for Sauk Valley to stay in his town, "Middle Town," which was between the other two towns.

Each town had its own steamboat landing, ferry, street names, post office, stores, and school. In March 1856, the Minnesota Legislature granted these towns the right to incorporate. They called the new community St. Cloud. The name came from John L. Wilson, who was fond of reading about Napoleon, who had a summer place in St. Cloud, a suburb of Paris, France.

Soon after, Brott left the community, Lowry died in 1865, but Wilson stayed on to his death in 1910, always working for and promoting his town.

Numerous events in those early years molded St. Cloud into the city that it is today, over 150 years later. In 1867, a private corporation built a toll bridge across the Mississippi on St. Germain Street. Two years later, the Minnesota State Normal School was established for the training of teachers. In 1878, the city purchased the toll bridge and made it free to the public. Four years later, St. Cloud's main streets were first lighted by gas, and the town received its first public library. A year later, the first telephone exchange opened. In 1884, the city's waterworks and sewer went online, and a dam was built across the Mississippi River. The town was shaken on April 14, 1886, when a cyclone tore through St. Cloud and Sauk Rapids, causing massive property damage and killing 73 people.

But St. Cloud kept growing. The very next year, the town's first streetcar line, operated by horses, began regular service. A year later, the city streetlights were switched to electric, and in 1889, the town economy received a boon when the Minnesota State Reformatory was established in St. Cloud. In 1890 and 1891, the Great Northern car shops were built in Waite Park, and the first electric streetcar line began operations.

In 1917, Samuel Pandolfo announced his plan to start Pan Motor Company in St. Cloud. In 1930, the municipal golf course was opened to the public, and in 1934, Whitney Airport opened on land donated to the city five years earlier by Mrs. A. G. Whitney.

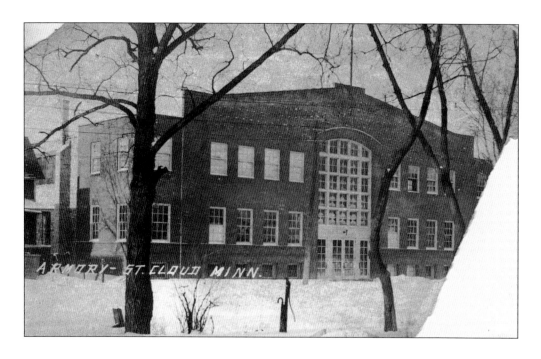

Here are a couple of bonus postcards that may stir the memory. Above is the St. Cloud Memorial Armory, which was built by Edward Hirt and Son in 1922. Many a dance was held here, and it was also the home of the city parks and recreation department. It was razed in 1982. Below is a card of the first Pan automobile sold in St. Cloud. It is a 1918 Model 250, which was named so from the fact they built 250 of these cars. In all, approximately 1,000 automobiles were assembled at the St. Cloud plant.

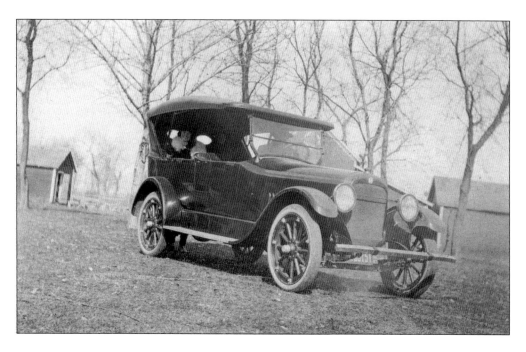

One

INDUSTRY AND TRANSPORTATION

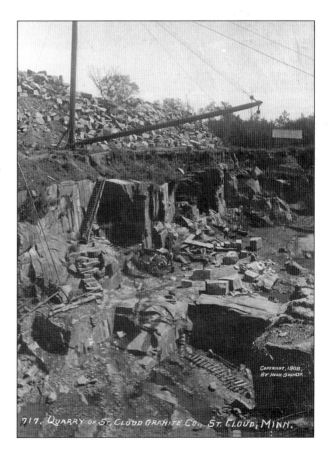

Incorporated in August of 1875, the St. Cloud Granite Company was 1 of 75 different granite companies in the St. Cloud area. The slogan "The Busy, Gritty, Granite City" was adopted in March 1913 to promote continuous growth of the industry and the St. Cloud community. The first successful granite company in Minnesota was Breen and Young, and their first order was for corners, steps, and trimmings for the U.S. Customs House and Post Office in St. Paul, Minnesota. The first use of the company's granite locally was for the foundation and basement of Old Main at the St. Cloud Normal School, which started in 1869 as Minnesota's third Normal School. Breen and Young sold out to the State of Minnesota in 1887, and their quarry was selected to be the site for the new state correctional facility.

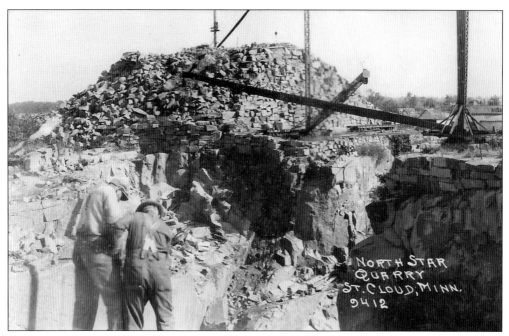

This is the North Star Quarry, which looks as though it has been worked for a long time—the bottom is a long ways down.

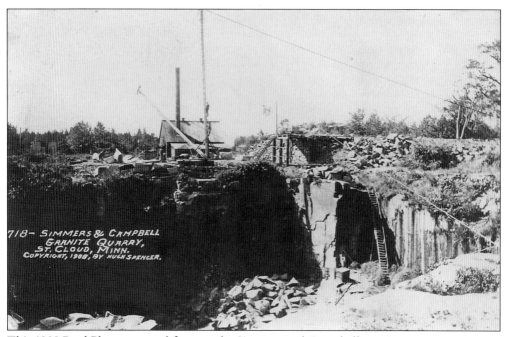

This 1908 Real Photo postcard features the Simmers and Campbell granite quarry.

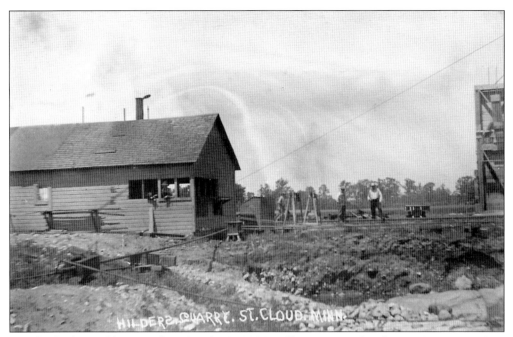

Gottfried Julius Hilder came from Sweden in 1886 and began quarrying the granite outcroppings near what was to become the reformatory. Hilder developed five major quarries, some of which were among the largest in the region. At their peak, Hilder's quarries employed 175 men. He died in 1921.

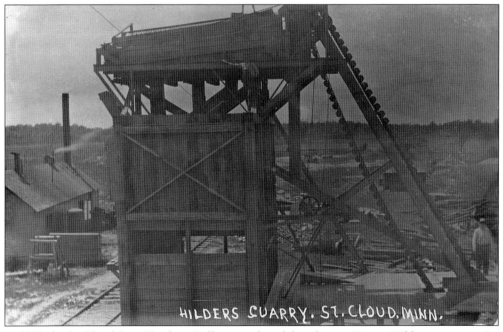

In 1934, the St. Cloud State Teachers College purchased the adjacent 51-acre Hilder quarry as a site for new biological labs and a park. This joined the 30 acres the college had previously purchased.

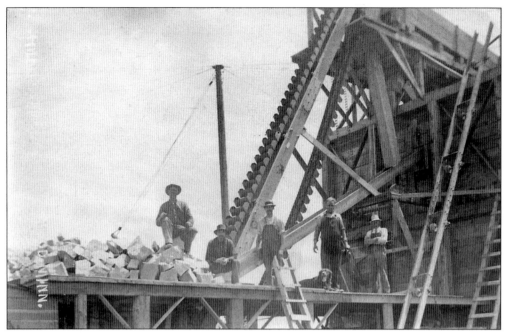
This image shows another rigging for the Hilder Granite Company.

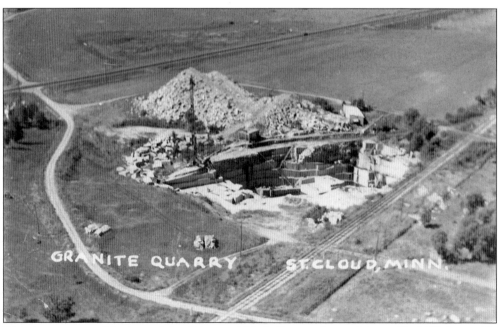
This is a great aerial view of the Diamond Pink Quarry located just off of Highway 23, approximately 3 miles west of St. Cloud.

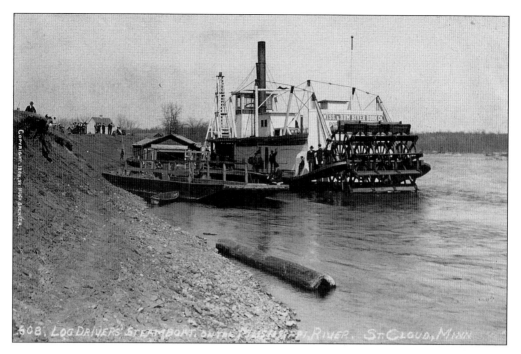

The log drivers' steamboat from the Mississippi and Rum River Boom Company did triple duty during the early logging days. They towed the Wannigans, seen below. The first was the cook's galley and quarters; the one to the right was the loggers' quarters. On the front of the steamboat is a pile-driving rig with which timbermen used to drive logs in vertically to help guide the logs away from the low areas and through the winding maze known as the Beaver Islands. The peak of the log drives was 1879, when 50 million feet of logs came through with a crew of 60 log drivers.

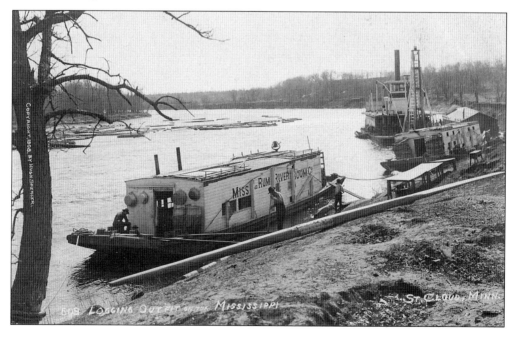

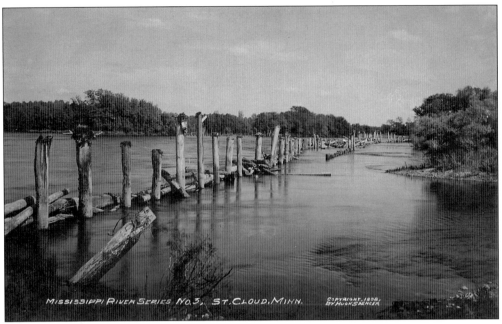

These pile-driven vertical logs have been lined up as a buffer to keep the logs from the bays and shallow parts of the river. This makes less work for the log drivers and takes advantage of the swift current in the main parts of the river to keep things moving faster.

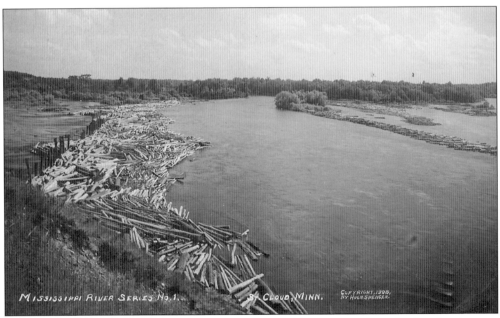

Here is a nice flow of logs riding the buffers, staying in the main track, and using the river.

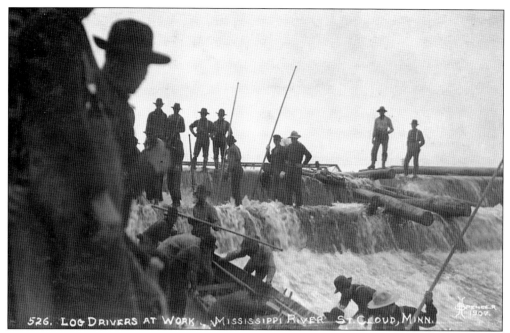

Log drivers are clearing a jam on the Tenth Street Dam to get the logs moving again down the river. They use cant hooks to pull the logs apart and sometimes off of the sandbars. Logging began in the St. Cloud area around 1865, when settlers in the area found little material for building homes and local trees weren't suitable. Most of the logs came from Little Falls or points south.

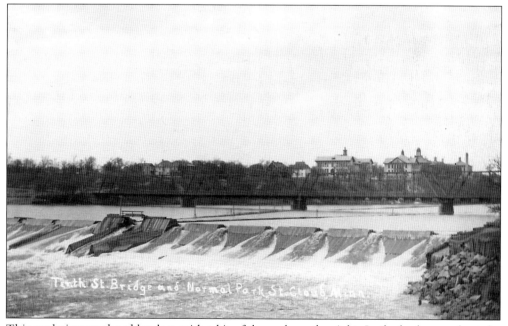

This card pictures the older dam with a bit of the park on the right. In the background are the Normal School and the Tenth Street Bridge.

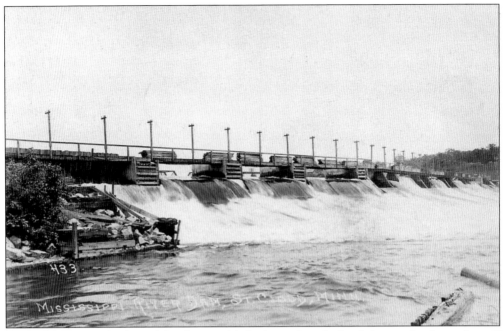

Here is another early shot of the dam, and it looks as though the sluiceway has been shut off or abandoned. The timbermen had been using that left corner for bringing the logs through the dam.

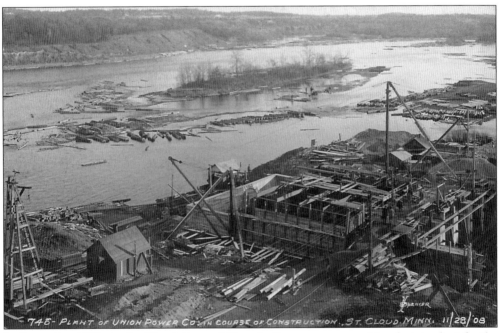

In December 1887, the St. Cloud Gas and Electric Company operated its electric plant for the first time. Under president Albert G. Whitney, the Union Power Company bought the St. Cloud Water Power Company in May 1908. Whitney had already owned the St. Cloud Dam and immediately started construction of a larger powerhouse at the foot of the canal.

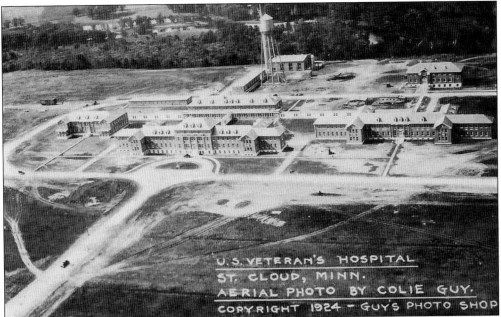

Colie Guy took this aerial postcard of the U.S. Veteran's Hospital upon its completion in 1924. There was much competition for the location of these hospitals, so land was given as an inducement for the Veterans Administration to locate its hospital here. The St. Cloud Commercial Club spearheaded the drive to raise the land purchase money from businesses and individuals, with the banks financing much of it. The dedication was held on September 15, 1924, and the first patient was admitted on September 24.

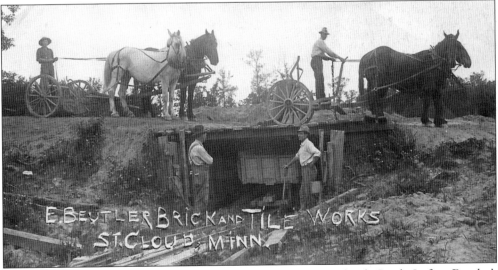

Ernest Beutler's yellow brickyard was in the area now known as Plumb Creek. In fact, Beutler's home, made of yellow brick, still stands there on what was the 100-acre site of his brickyard. Brick manufacturing was a very important industry in St. Cloud from 1860 until the last yard closed during the Depression in 1936.

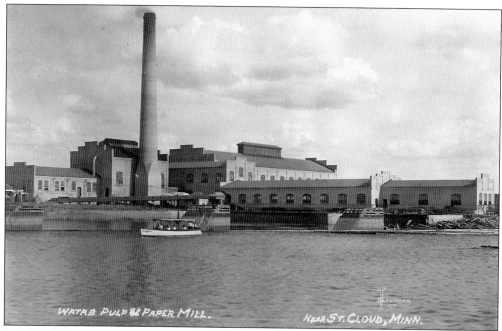

This Real Photo postcard of the Watab Pulp and Paper Mill was taken from above the dam on the Mississippi River. Note the excursion boat that was based somewhere up the river.

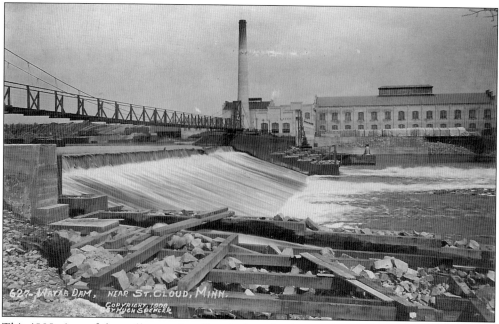

This 1908 view of the mill was taken from below the dam. Of note here is the swing bridge, sitting above the dam. The workers who lived on the west side of the river used this to go back and forth to work.

This is a Real Photo postcard advertising the Pan automobile. Samuel Conner Pandolfo came to St. Cloud in early 1917 with the purpose of building automobiles. He wanted to construct the best automobile that he could for $950. Starting with the acquisition of 47.75 acres of land on the western end of St. Cloud, he built a large factory, power plant, and an independent heat and water system.

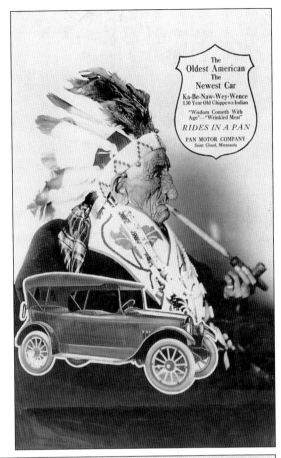

This is the northeast corner of the factory at Thirty-Third Avenue North and Cooper Avenue. The sign above the corner became the company logo, featuring the slogan "Queen of the Road."

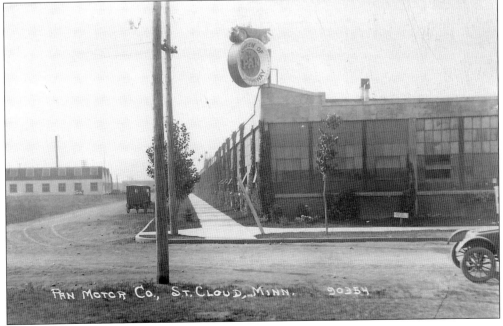

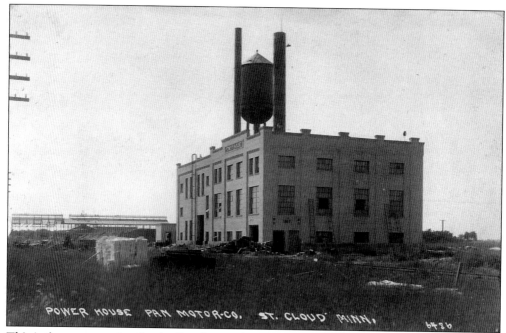

This is the power station for the Pan Automobile Company.

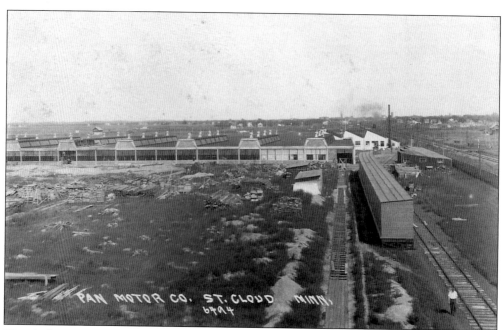

Here is the Pan Automobile Company factory. Also visible are the railroad connections.

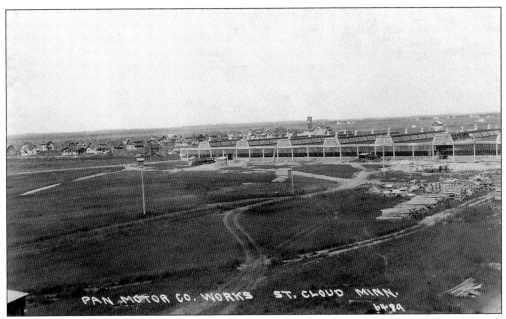

In the background of this factory view are the homes that Pandolfo built for employees of his Pan Automobile Company.

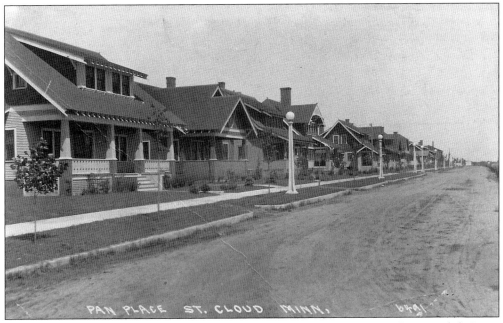

Here is a sample of the homes Samuel Pandolfo built for his employees. This is Eighth Street North, now also known as Veterans Drive. He built 50 homes of approximately 25 different designs, for sale or lease to his employees, during 1917 and 1918. Though the houses are now over 90 years old, most are still standing and in use.

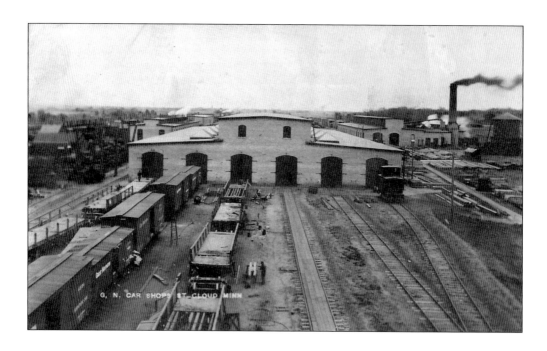

In 1878, James J. Hill acquired what became the Great Northern Railroad Company. He had his eye on St. Cloud and started acquiring land. In 1890, ground was broken on five buildings, all built of cream-colored brick and set on granite foundations. The railroad hired 500 men, instantly becoming one of St. Cloud's major employers. By 1926, there were 1,500 men working for the building and repairing boxcars. The above postcard is the main building, and the postcard below shows the blacksmith shop. Things slowed down by the 1980s, and in 1986 the car shops were moved to Montana.

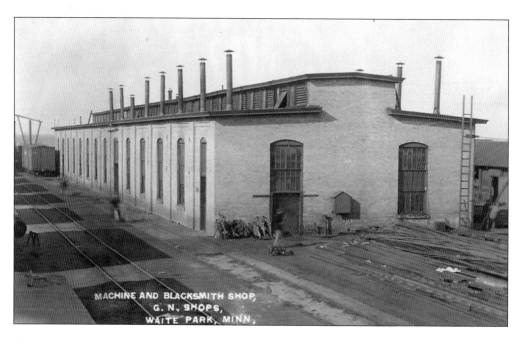

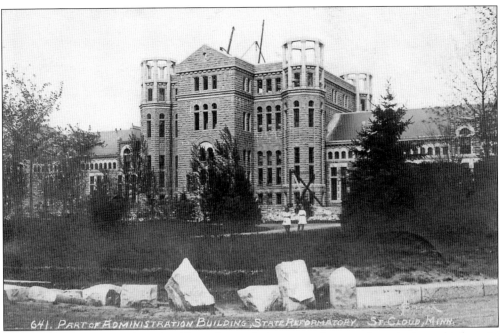

641. PART OF ADMINISTRATION BUILDING, STATE REFORMATORY. ST. CLOUD, MINN.

In 1885, the Minnesota State Legislature's search for a second state prison site brought them to East St. Cloud, where it purchased 240 acres, including some 60 acres of granite. Minnesota State Reformatory for Men opened for business on October 15, 1889. The granite quarry provided the inmates with their principal occupation during the early years. In 1905, the granite wall was started; granite blocks were cut and placed by the inmates. When the wall was completed in 1922, it stood 22 feet high and was 4 feet, 6 inches thick at grade. It is the largest wall in the United States and the second-longest wall in the world next to the Great Wall of China. The two postcard images, taken while the towers were still under construction, show the front of the building from different angles.

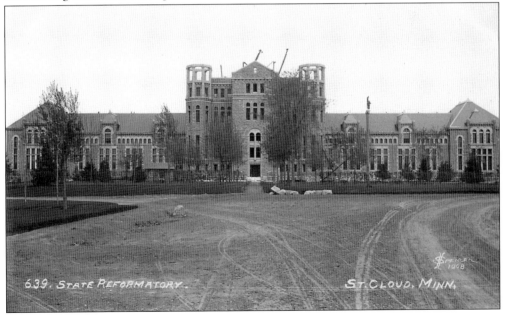

639. STATE REFORMATORY. ST. CLOUD, MINN.

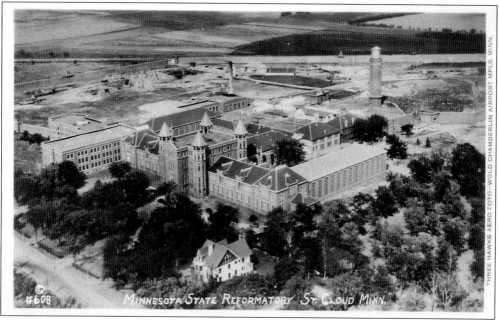

Here is a great aerial view of the reformatory that shows much of the whole complex. A group out of Wold Chamberlain Airport in Minneapolis took the photograph in 1934.

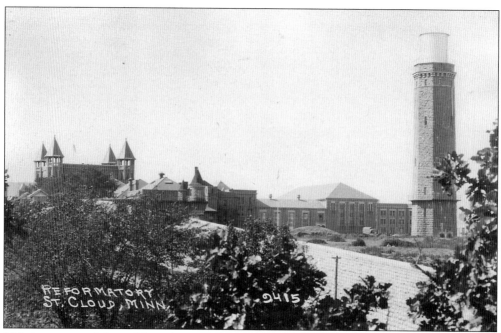

This is an unusual shot of the reformatory that looks north over the south wall and the back of the administration buildings.

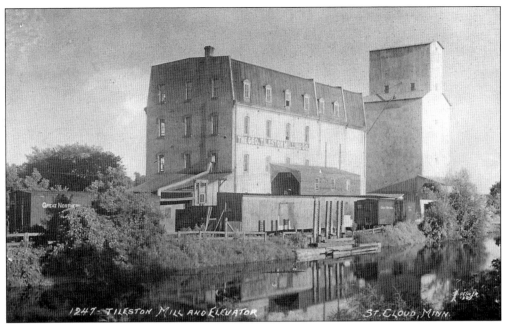

In 1888, brilliant young entrepreneur George Tileston built the Tileston Mill on the west side of the dam near Tail Race No. 1, one of the spots where the water flowed around the dam and powered the mill (and the St. Cloud Electric Company, originally). The mill burned in 1915 and was rebuilt, only to be demolished in 1934. Tileston died tragically in 1895 at the age of 37. Rushing out of the office to bring the mail to the post office, he jumped into his wagon, startling his horse, which reared up and backed the buggy into the millrace, and Tileston drowned. He left a wife and three children. Pictured above are the mill and elevator, and below a mill employee is going into work on the machinery over the millrace.

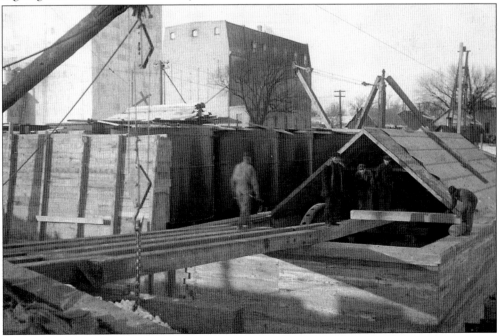

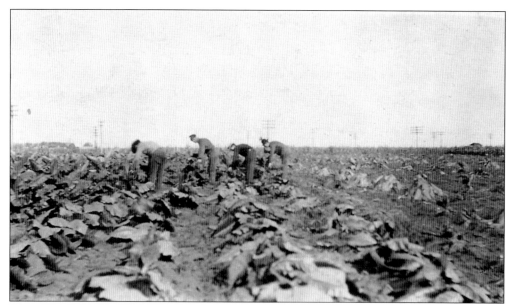

These farmers are working the tobacco crop at the Davis tobacco field south of St. Cloud. In 1912, tobacco was one of the rising crops in the area. Farmers found a ready market and a profit of $100 to $150 per acre.

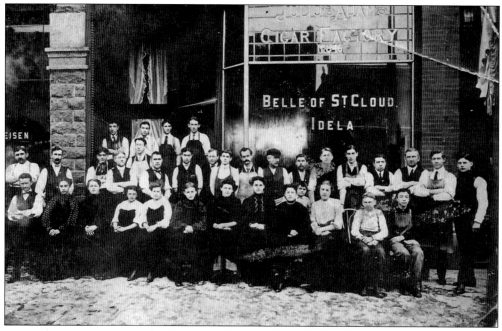

Pictured in 1907 are the building and crew of the Julius Adams Cigar Factory, located at 712 St. Germain Street. That year, the factory turned out 1.5 million cigars, employed 36 workers, and had a payroll of $1,500 per month. Cigar making began winding down after World War I, as the boys came home with a new habit—cigarettes.

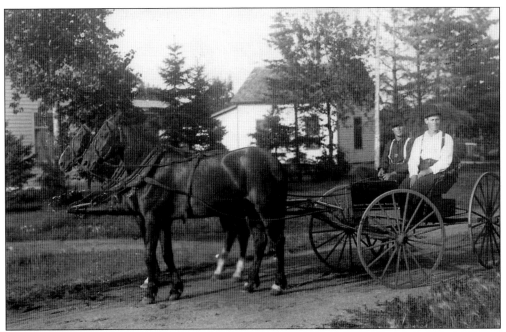

This 1914 postcard shows a nice-looking team, but the real story is on the back of the card, where Joe writes to Lillian, who is in Bemidji, telling her if she were only in St. Cloud, they would have a dandy time. "So jump in the buggy and drive back," he urges. He also states, "The ponies are good."

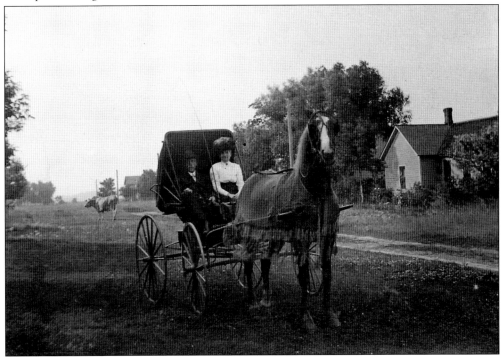

Everyone is dressed up in this one-horse buggy, including the horse, which wears its best net. It looks as if the cow behind them is going to be left home today.

27

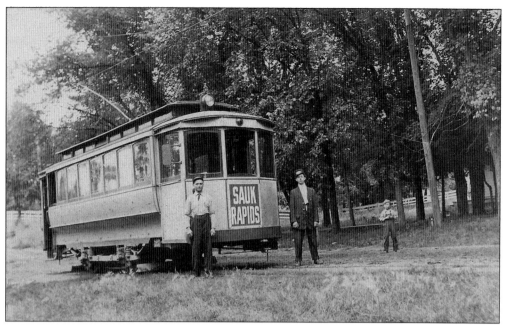

A streetcar has reached the end of the line in Sauk Rapids. Here the conductor would reverse the seats, take the cash box to the front, and be ready for the return trip. There was an incline at the end; occasionally mischievous boys would soap the tracks, and the wheels would spin in vain. Sometimes the conductor would leap from his trolley and chase the boys.

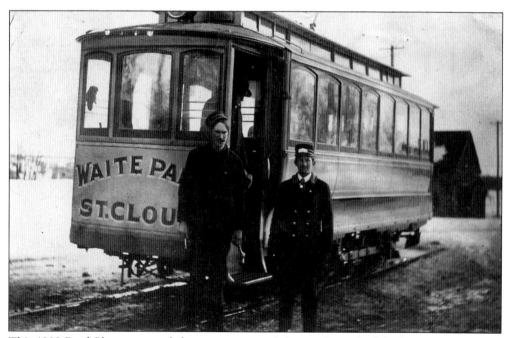

This 1909 Real Photo postcard shows a streetcar sitting at the end of the line in Waite Park. The conductor on the left is Bill Clayton, and the young assistant on the right is 16-year-old John H. Smith.

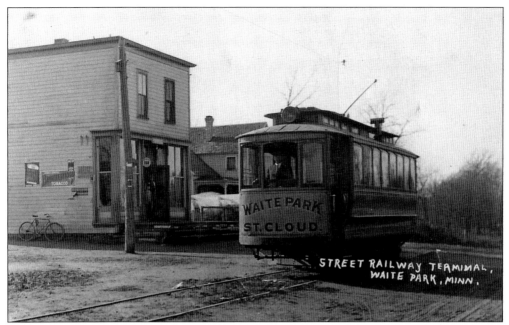

This is the streetcar terminal just before the end of the line in Waite Park. The car has stopped in front of Elmer Stein's store. Elmer stands in the doorway. To the right (north) of the streetcar are the Great Northern Railroad Car Shops.

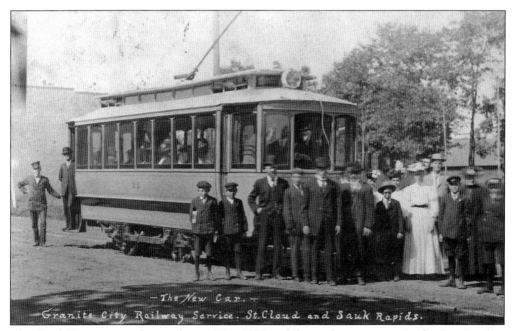

This Real Photo postcard was taken in May 1909 and shows the newest car in the Granite City Railway Service, which ran between St. Cloud and Sauk Rapids.

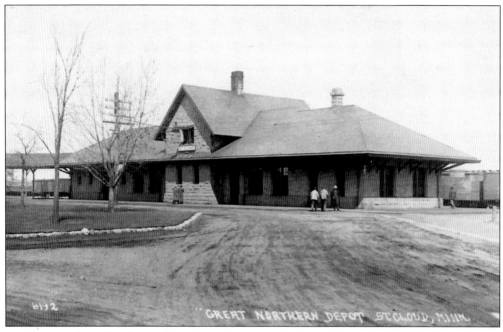

In this view from the front of the Great Northern Railroad Depot in St. Cloud, notice the covered walkway on the left side of the image. The tracks split there, with one set going east and one set going south.

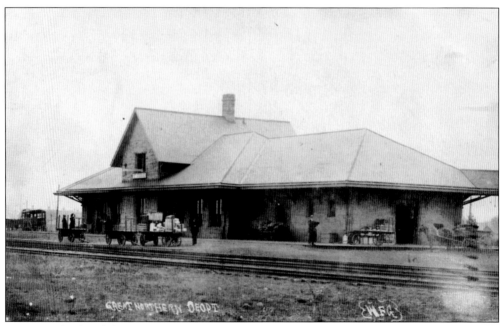

Here, trackside of the Great Northern Depot, railroad employees would load and unload passengers, freight, and mail.

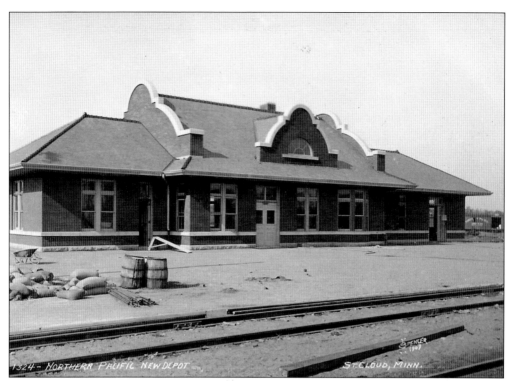

Workers were just finishing the Northern Pacific Depot in 1909 when this shot was taken. The new depot replaced an old wooden structure located a block south at the corner of East St. Germain and Sixth Avenue Northeast. After the new depot opened on November 13, 1909, the old depot was cut in half and moved 50 yards south to be used as a freight depot. The depot seen here is in use 100 years later as an Amtrak passenger station.

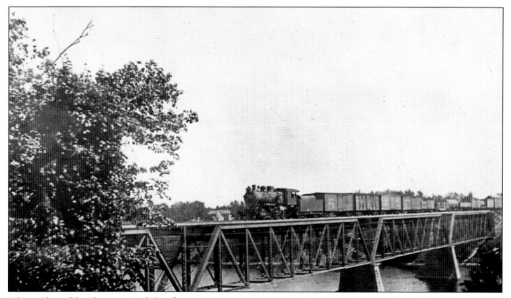

The railroad bridge carried the first passenger train across here on August 25, 1872, and stopped at the new Great Northern Depot. The bridge was rebuilt in 1892 and in 1922.

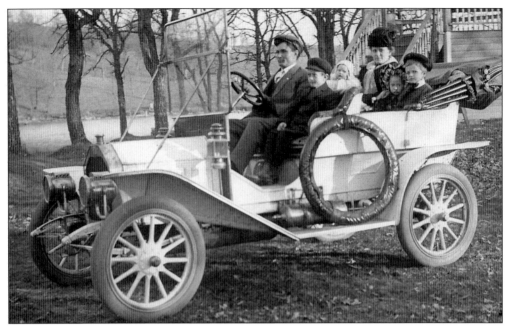

The writer on the back of the postcard explains that the family has just taken a trip to Cold Spring. Based on the car it is driving, this looks to have been a fairly prosperous family. This is a 1913 Buick Touring Car.

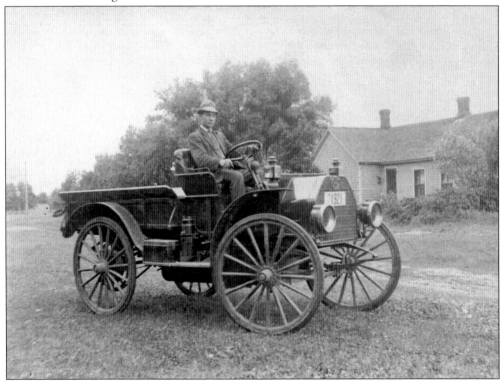

This great-looking rig is a 1908 International High Wheeler pick-up that was most likely purchased at the International Harvesting Company on Sixth Avenue North. They sold a lot of them.

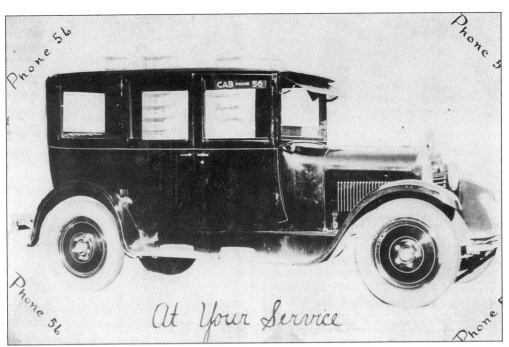

The owners of Stevenson's Taxi Service, located at 18 Fifth Avenue North, bought the business from Benjamin Fearing in 1923 and obtained a Yellow Cab franchise. They sold it to Einar Anderson and Ron Kreatz in 1944. This vehicle is a 1928 Hupmobile Century Eight.

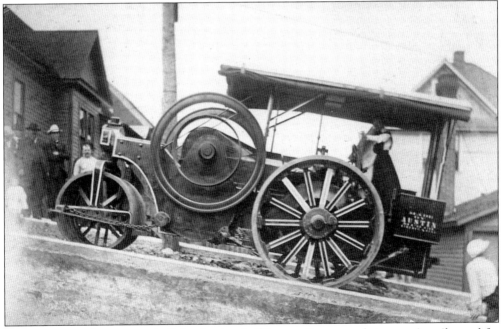

This is a piece of equipment built by the Austin Western Company that was primarily used for building roads. The inscription on the back of the card explains that the salesman brought it over to a home in Sauk Rapids, hoping to sell it to the Benton County Roads Department. It appears to have a heavy roller on the front and an oversized flywheel on the side.

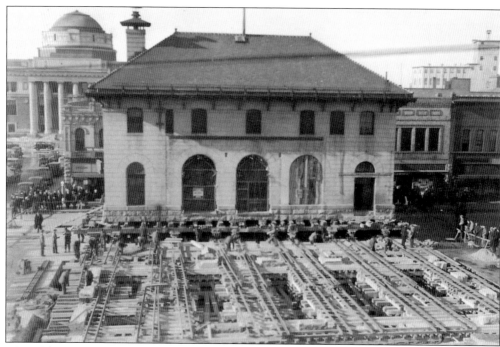

This old U.S. Federal Building and Post Office stood at 720 West St. Germain Street. On February 15, 1937, builders used 700 sets of jacks to lift this solid granite building and set it on nine sets of steel rail running along St. Germain Street. Then it was pulled by horses 4.5 blocks east at the rate of 150 feet per day. As it crept along, workers had to prop up the basement walls of many stores in its path to keep them from caving in from the weight. Children set pennies on the rails for flattening. After the building finally reached its destination, it reopened as the new St. Cloud City Hall. In 1986, less than 50 years later, despite protests and a lawsuit, the building was demolished to make room for the development of the new St. Cloud Civic Center. The above postcard shows the building as it was being moved out to the street, and the card below shows the building on its way. Like the city hall, the buildings seen on the right side of the picture are now gone.

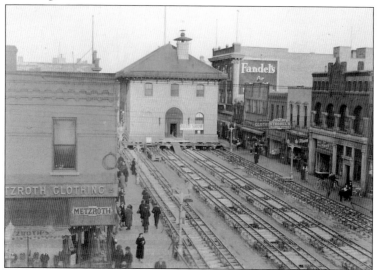

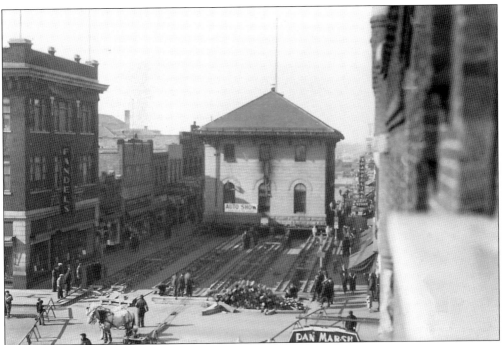

The card above shows the view that greeted people as they approached St. Cloud's most popular corner of the day, Sixth Avenue and St. Germain Street. Fandel's Department Store stood on the left, kitty-corner to Dan Marsh's drugstore across the intersection. Marsh's store featured a coffee shop, which became known for its slogan, "Meet Me at Marsh's"—for many years, everyone did. The card below shows the arrival of the city hall building at 314 St. Germain Street between the police station and Security Blank Book and Printing Company.

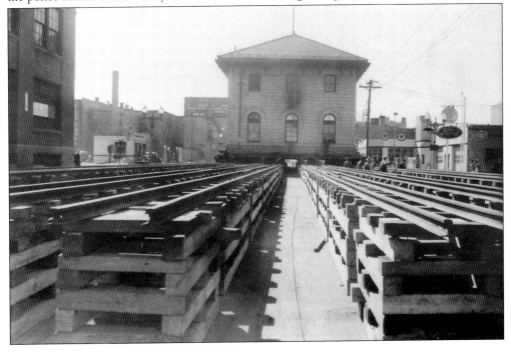

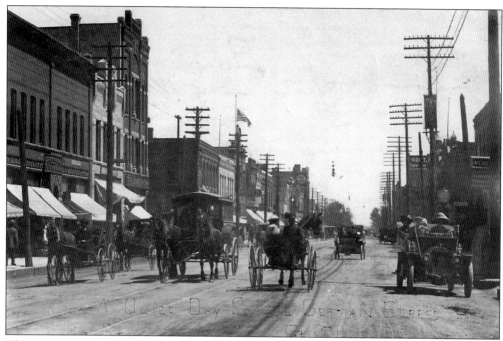

This vintage postcard, taken on the 900 block of St. Germain Street, shows every form of street transportation available in St. Cloud in the early 20th century, both horse drawn and gasoline powered.

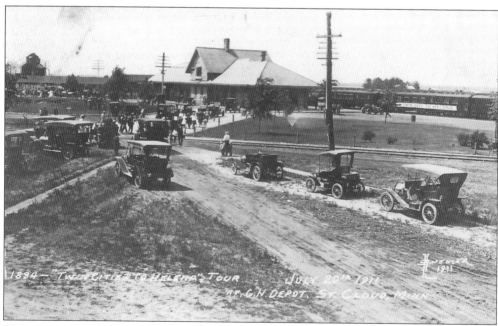

This early automobile tour has stopped at the Great Northern station in St. Cloud on the way to Great Falls, Montana. The men drove the vehicles; the family rode the train, which was also used for sleeping and meals. It was a handy way to travel.

Two

MAIN STREET AND PUBLIC BUILDINGS

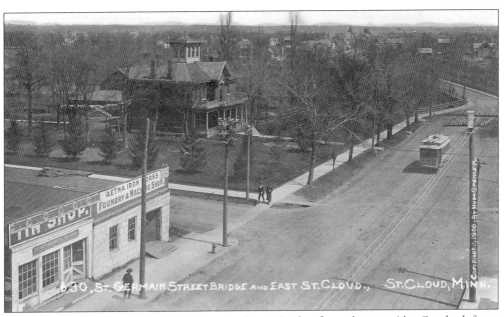

This is the approach to the old St. Germain Street Bridge from the east side. On the left are William Theilman's tin shop and the Aetna Ironworks. Across Fourth Avenue is the Scott-Zapp house, which became the Tschumperlin Funeral Home and then the Tschumperlin Williams Funeral Home before falling to the St. Cloud Civic Center development. Note the widow's walk on top of the house.

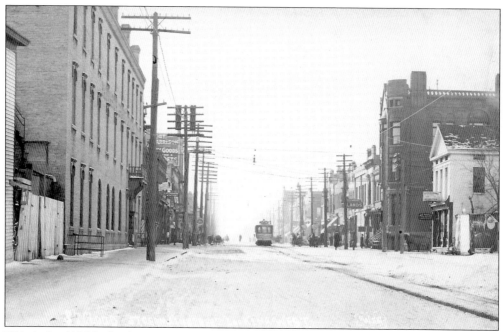

This is the 400 block of St. Germain Street looking west. On the left is the peak of the wood livery barn for the Grand Central Hotel. The next tall brick building is the Grand Central Hotel. On the right is a white building that housed tailor Max Hieber. Across Fifth Avenue stands the First National Bank.

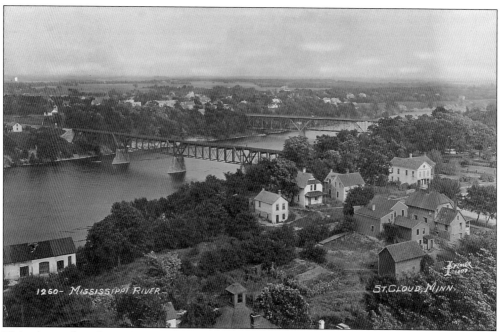

This view, taken from the steeple of the cathedral, shows the railroad bridge and the wagon bridge crossing the Mississippi River. The larger white home to the right is the residence of John Wilson, known as "the Father of St. Cloud."

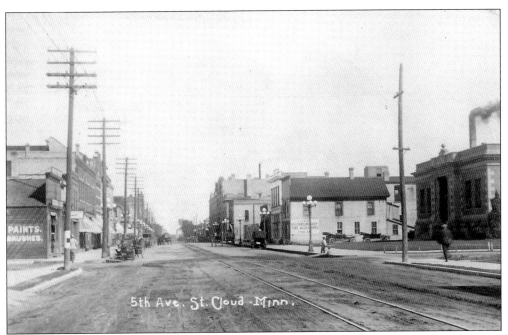

This image looks north on Fifth Avenue across Second Street South. The Carnegie Library stands to the right. Note the streetcar tracks heading north from the car barns to St. Germain Street, where the trolleys will either turn right towards Sauk Rapids or left towards Waite Park.

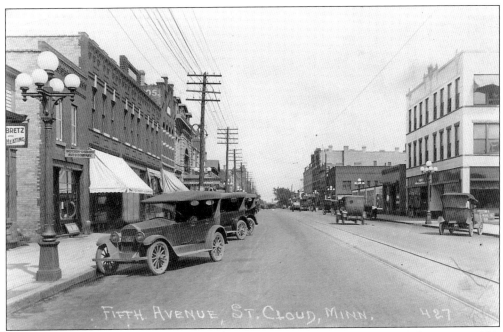

As seen here looking north on Fifth Avenue, traffic was starting to get a little heavier in 1921. The first structure on the right is the new St. Cloud Laundry building.

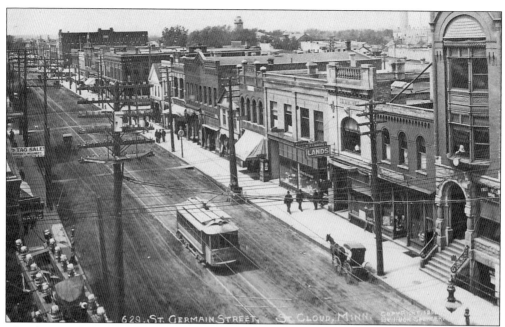

This shows the north side of the 500 block of St. Germain Street. The second building from the right was George Spencer's drugstore. Spencer was the father of photographer Hugh Spencer, who clerked at the store while building up his photography business. About 1914, the building was torn down and rebuilt as the western half of the First National Bank building. Note that all of the wires in the photograph seem to be heading into the bank building; the telephone company was on the second floor.

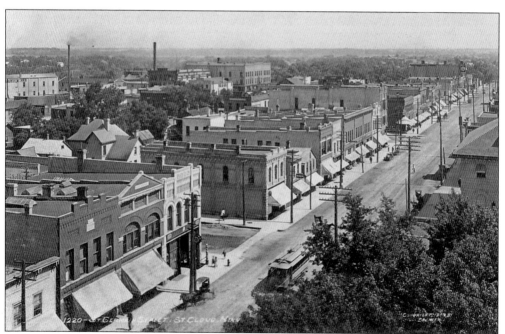

Here is a bird's-eye view of St. Germain Street's 700 block. At middle right is the old federal building, which would later be moved down the street and become city hall.

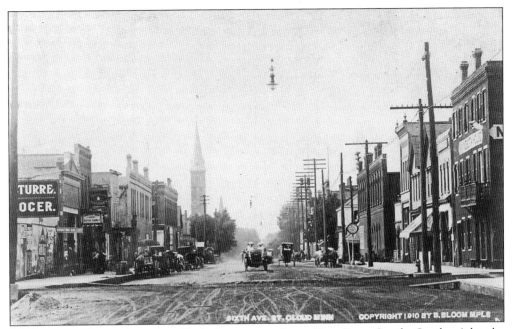

This image looks northward up Sixth Avenue, starting at First Street South. On the right, the first block begins at the Minnesota House hotel and continues to Ladner Hardware. Across St. Germain Street is Mathias Weiren's Saloon.

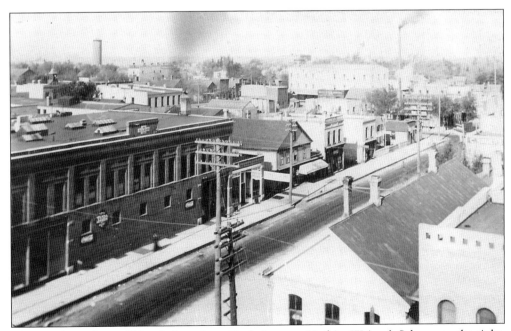

This is a closer shot, still headed north on Sixth Avenue. Mathias Weiren's Saloon, on the right, would be replaced by Dan Marsh Drug. On the left stands the new Lahr Building.

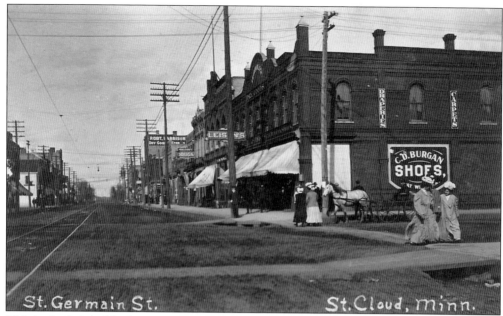

This is the Leisen block on the south side of St. Germain Street heading east from Seventh Avenue on the 600 block. Note the dirt streets, wooden sidewalks, long dresses, and young women dressed for a stroll. This building opened as J. J. Leisen Drygoods and Millinery in September 1889 and went out of business in 1916; the building later reopened as a Kresge Five and Ten Cent Store.

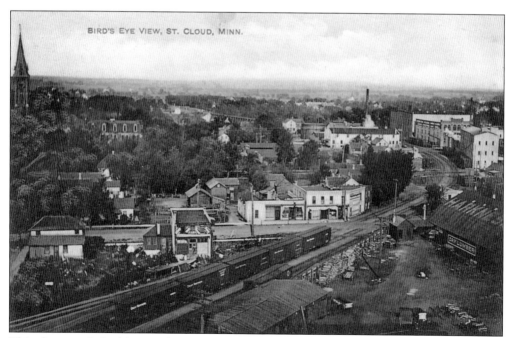

This photograph, looking north and east, was probably taken from the old water tower near the present-day post office. About the only thing that is the same here is the Carter Building, the top building on the right side. Everything else is gone or vastly altered.

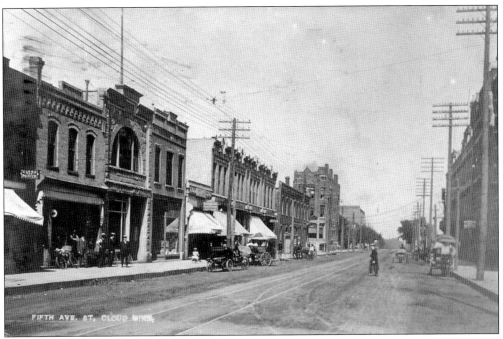

It is 1909 here on Fifth Avenue South, and things are moving. All of the dandies on the left are floating between Oscar Becker's Confectionery and Ernest Titus's Saloon.

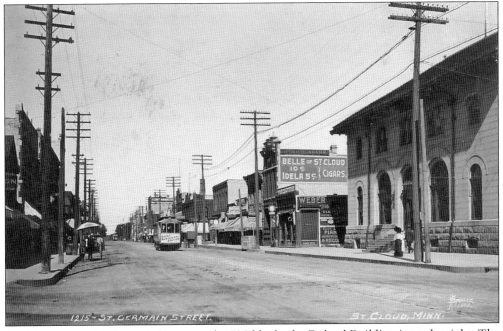

Looking east on St. Germain Street on the 700 block, the Federal Building is on the right. The streetcar coming toward the camera is heading for the Great Northern Depot. On the left, a horse pulls a cart with an umbrella that reads, "Clothiers."

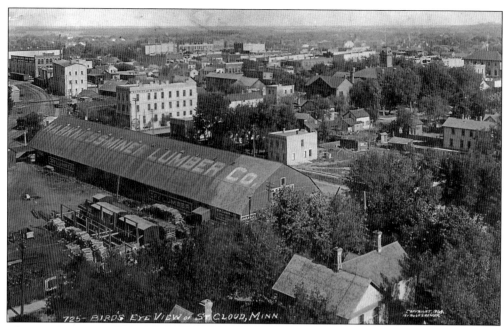

There is a lot to see in this 1908 Real Photo postcard. On the left is the Harkness-Miner Lumber Company, the larger building in front is the Merchants Hotel, and farther to the left (or east) are the Ervin Mill and the International Harvesting Company building.

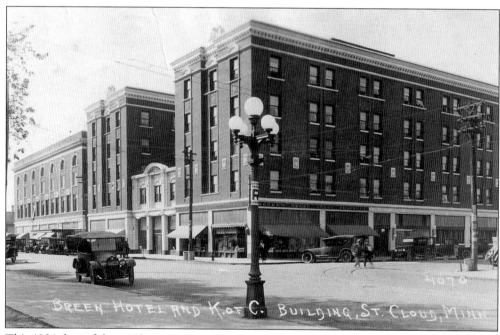

This 1924 shot of the southeast corner of the Breen Hotel and the K. C. Building shows that it is now completed. The next step will be to get the theatre installed.

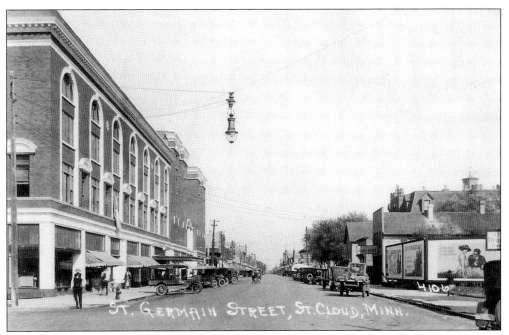

This is the 900 block of St. Germain Street in 1922 looking east. There is not much development on the south side of the block.

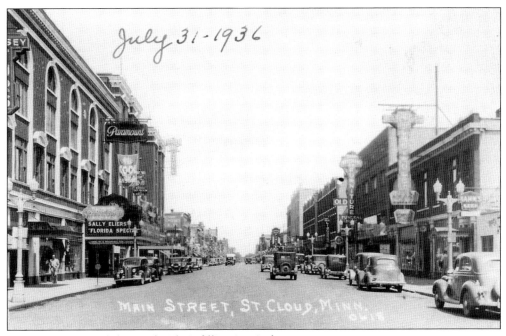

Now it is 1936, and the south side is filling in nicely.

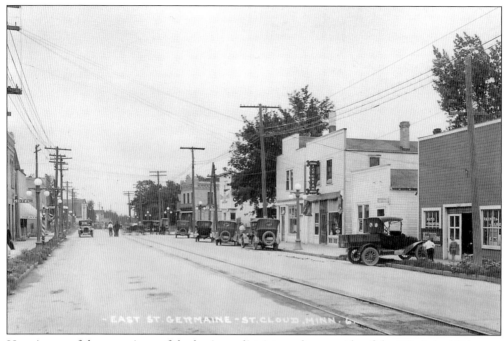

Here is one of the rare views of the business district on the east side of the Mississippi River.

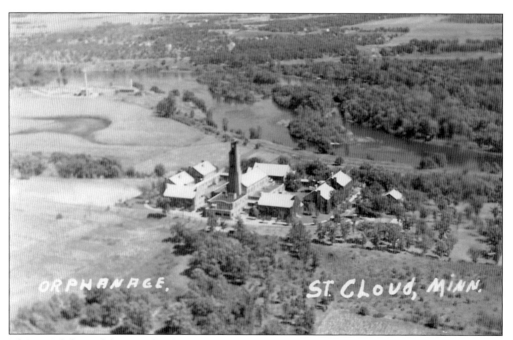

This aerial shot of the St. Cloud Orphanage, now known as the Children's Home, shows it sat well above the Mississippi and enjoyed a nice land buffer.

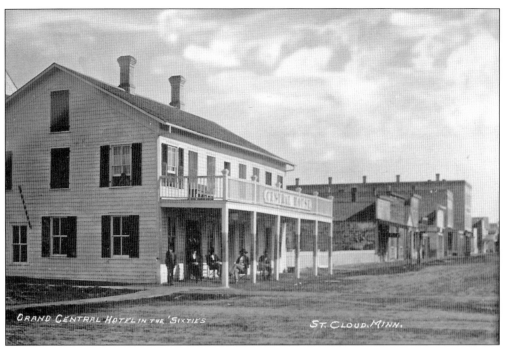

This has been a popular hotel block since 1855, when Anton Edelbroch built the Edelbroch Inn. After improvements, it became the Central House in the 1860s. In 1888, Josiah Hayward built the Grand Central Hotel, and the southeast corner of St. Germain Street and Fifth Avenue was confirmed as a prime spot for lodging.

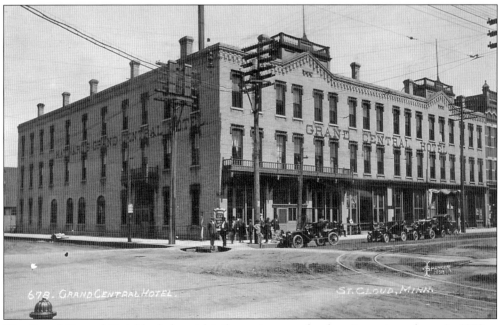

The Grand Central Hotel had almost hit the century mark when it was torn down in 1972 as part of an urban renewal plan. In 1990, after spending several years as an empty lot, and then serving as the site of a bus terminal, the land became home to the nine-story Radisson Hotel.

47

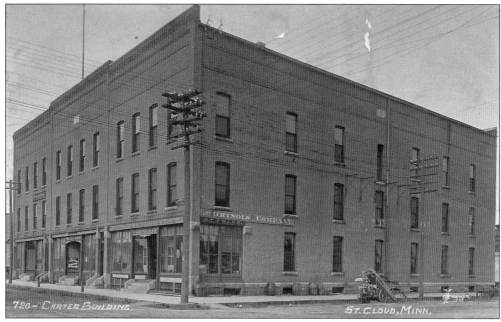

Martha Carter sent this postcard in September 1909 to her cousin Minnie in Paynesville. On the back, Martha thanks her for a pair of booties she made and states that she wanted to show Minnie a picture of the building Martha's husband owned.

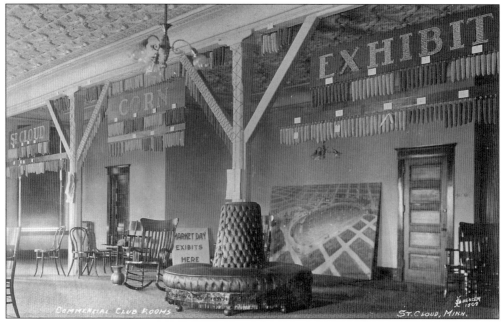

Located upstairs in the Carter Building at First Street North and Fifth Avenue North, the Commercial Club rooms were a collective forerunner of the St. Cloud Civic Center and were used for business and community meetings and exhibits. The Commercial Club was not unlike the latter-day St. Cloud Chamber of Commerce. The message on the back of this postcard tells of using the club rooms as a rehearsal hall for a youth choral group, which was going to put on a program to raise money for the poor.

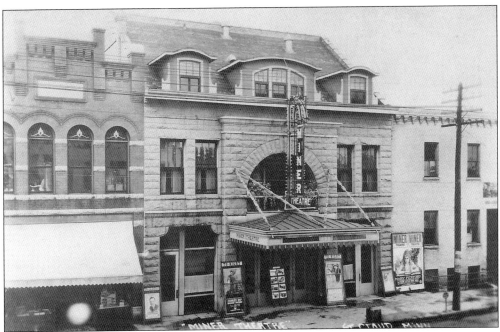

This building at 115 Fifth Avenue South was the Davidson Opera House. It suffered a major fire in 1913, burning the top floor off. This images shows the opera house after it was rebuilt and had become the Miner Theatre. Later it would open and close as the Roxy Theatre. The next closing marked the end of the facility's theatre era, after which the building was renovated and leased as office space.

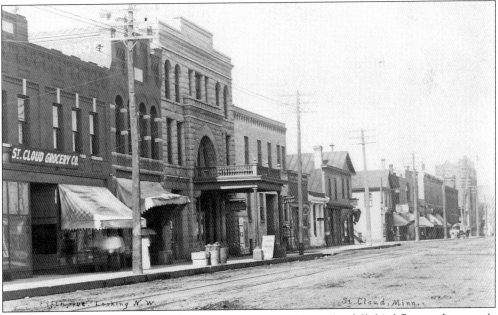

This postcard shows the Davidson Opera House at its zenith, with a full third floor and a second-floor smoking balcony that reached the street and served as a canopy under which men could drop off women on rainy nights. After a fire on the night of February 5, 1913, nothing was left but the shell. Owner E. T. Davidson promptly announced his intentions to rebuild, and he did.

49

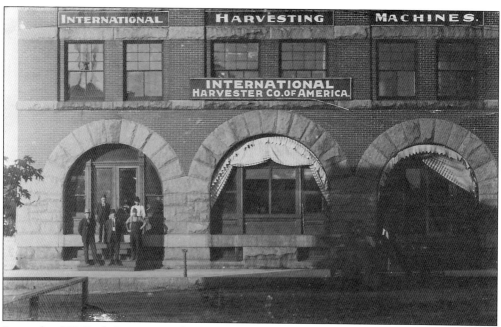

Located at 112 Sixth Avenue North, this was originally known as the McCormick Harvesting Machine Company building. Erected in 1889, after the firm had outgrown a building on St. Germain Street, it erected this very substantial structure of solid red pressed brick with a granite foundation and granite trim. In the basement was a water motor, which powered an elevator with a 4,000-pound capacity.

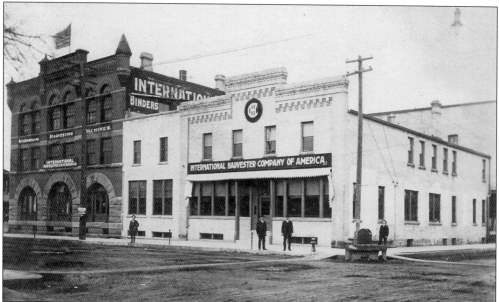

The rapid growth of heavy truck sales led to a new building for the merged International Harvester Company at 102–114 Sixth Avenue North, which was built from 1912–1914. After several successful years here, the repair facilities again moved to the east side on St. Germain Street, just west of the railroad tracks. Upon the demolition of these buildings, the land became truck parking for the Nash Finch Company, which had taken over the Carter Building.

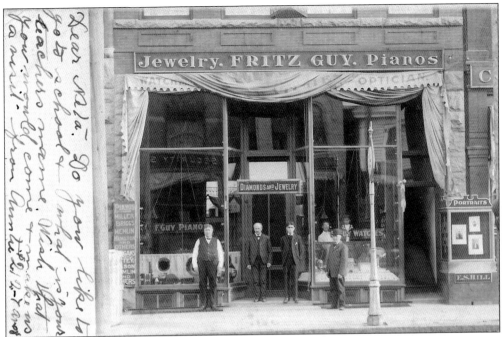

Born in Switzerland, Fritz Guy came to St. Cloud in 1886. Guy's store was located at 522 St. Germain Street, where he advertised as a jeweler, watchmaker, and optician and also sold pianos and such musical merchandise as Edison Phonographs and Victor Talking Machines. His son George took over the jewelry section, his son Albert inherited the optical section, and son Colie set up his own photography business.

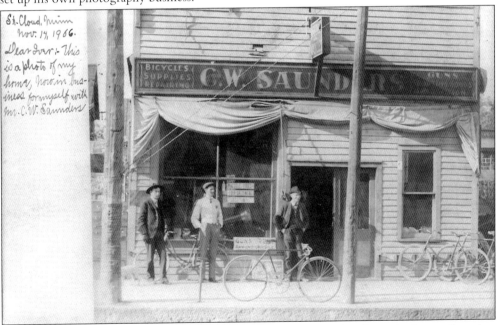

In 1906, Charles W. Saunder's bicycle shop was located at 409 St. Germain Street. Saunders was in the bicycle business from 1904 to 1927 when Jim Hermanson took over. Saunders also managed several theatres in St. Cloud for many years.

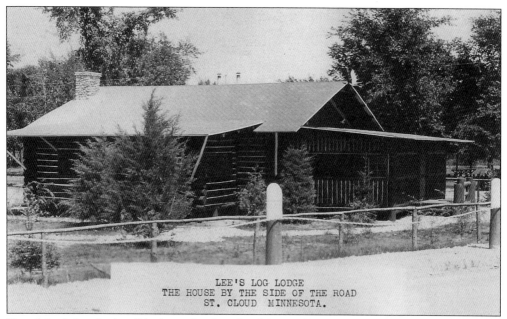

Here is Lee's Log Lodge, "the house by the side of the road," which was a well-known restaurant and a favorite spot for wedding receptions and parties. It served the area from 1925 into the 1950s. It was vacant from then until 1965, when it burned.

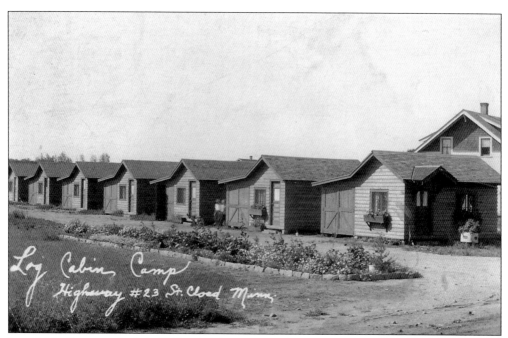

Log Cabin Camp was built in 1932 on Highway 23 at Thirty-Seventh Avenue and Division Street. These cabins have been gone for 50 years, but in the summer of 2009, two new motels were built in the same vicinity. The buildings may change, but the need to stop and rest continues.

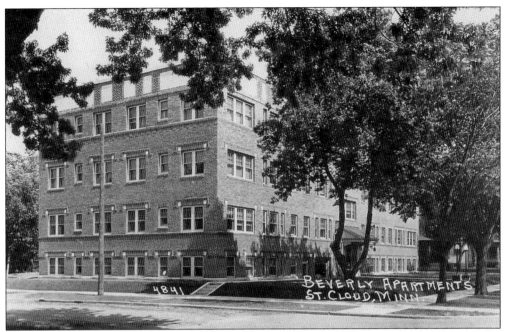

The Beverly Apartments, located in the 300 block of Fourth Avenue South, were completed during the summer of 1924 at a cost of $125,000. They were said to have all of the modern conveniences, including a grocery store in the building's basement. Close to downtown and the college, the apartments were easy to keep full.

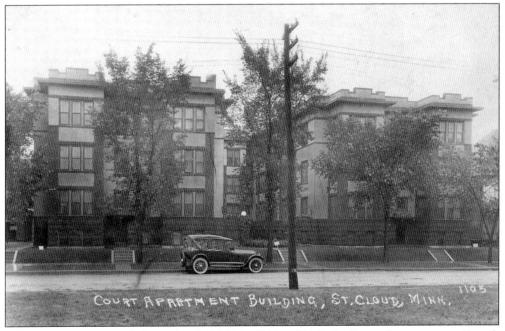

A group of investors pooled together $50,000 in 1918 and built the Court Apartments on Fourth Avenue South just off of Second Street South. This was St. Cloud's first apartment building. The U-shaped brick building was designed by renowned architect and area native Leo Schaefer.

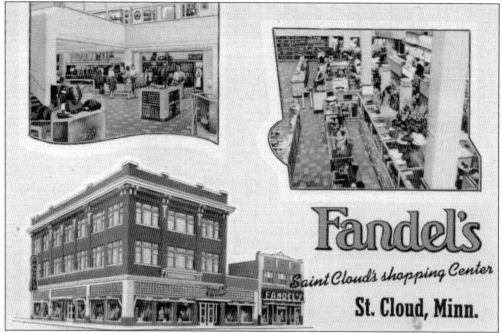

Fandel's Department Store sat on the southwest corner of Sixth Avenue South and St. Germain Street.

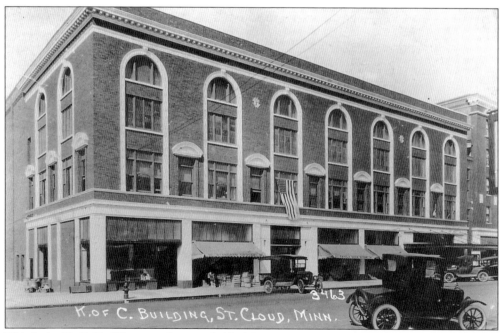

This is the K. C. Building, on the west half of the 900 block of St. Germain Street, which was completed in 1922. When Henry Breen developed the Breen Hotel on the east half of the block in 1920, he moved his home from this property down to Sixteenth and St. Germain Streets, where it still stands.

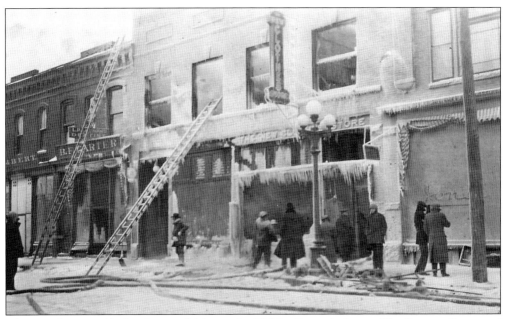

This was the New Clothes Store, which stood at 508 St. Germain Street. The fire was discovered at 8:00 a.m. on February 6, 1914. The store's owners, Oscar Magnuson and William J. Rau, survived the tremendous loss and reopened at 512 St. Germain Street.

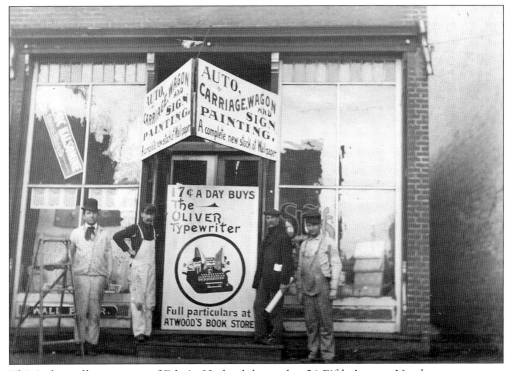

This is the wallpaper store of Edwin Harland, located at 26 Fifth Avenue North.

55

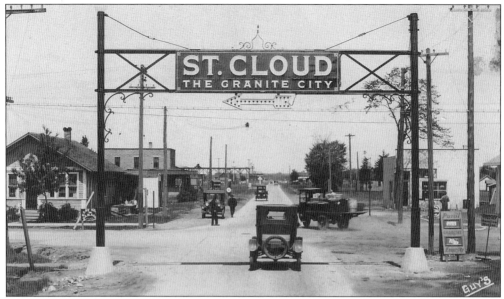

This gateway stood 20 feet tall and 30 feet wide, and it was illuminated at night by 300 electric lightbulbs. The lights led to the gateway's downfall, as its bulbs were continually shaken loose by all of the truck traffic. A newly appointed manager of the St. Cloud Chamber of Commerce, charged with maintaining the sign, made the decision to scrap it in the 1950s. He was almost lynched by the east side merchants, who advised him to stay on the west side of the river.

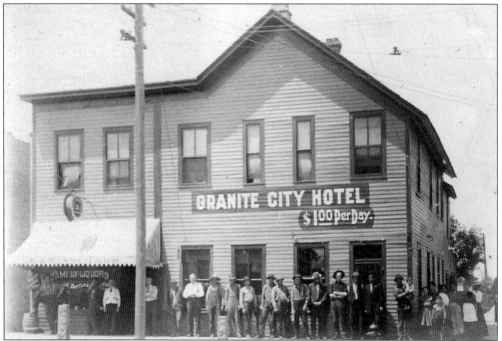

The Granite City Hotel, located at 423 East St. Germain Street, opened as the Albion Hotel in 1894. From 1908 to 1938, it was the Granite City Hotel. In 1938, the Ace Bar was moved here from 809 St. Germain, and the Rossmeisels took it over in 1939. After several fires, the Ace Bar and Café still sits on the same site, though in a modern building.

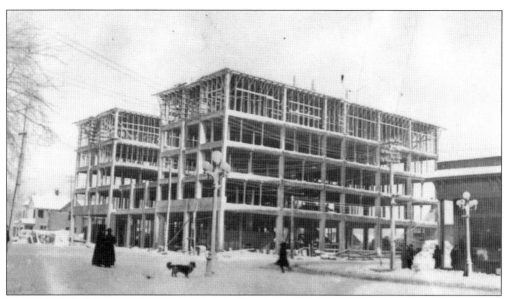

At 905 St. Germain Street, the new Breen Hotel was on schedule and had its grand opening on the day after Easter on March 28, 1921. The opening banquet drew over 500 guests. Visible here on the left is Henry Breen's home, packed and ready to travel six blocks down the street to 1529 St. Germain Street.

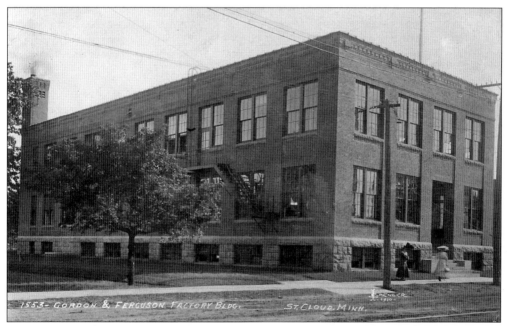

The Ferguson Glove Factory, in the 300 block of St. Germain Street, was eventually joined by the police station and city hall between Fourth Street and the river. David Abeles of the Abeles Clothing Store was a friend of the Fergusons and was able to persuade them to move their factory from St. Paul to St. Cloud.

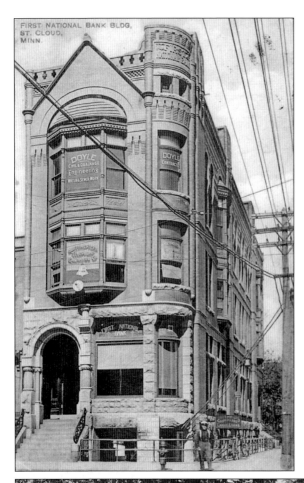

This classy looking building, made of pressed red brick, was the First National Bank. Built in 1890 and sitting on the northwest corner of Fifth Avenue and St. Germain Street, it was expanded 26 years later when the western half of the building was added. Most people today look at it and assume it was all built at the same time.

This golf course was built in 1920 on a 113-acre site on the west side of the Mississippi. The clubhouse was completed in 1922 at a cost of $25,000. It was replaced with a new building in 1959.

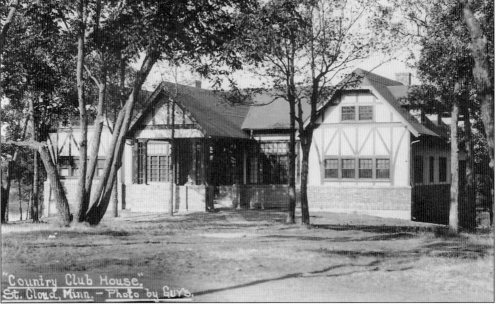

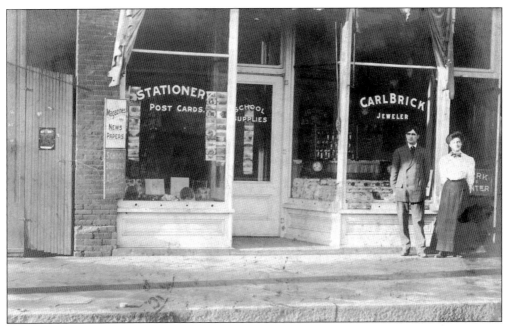

This postcard features the jewelry shop of Carl Brick, which was located at 19 Fifth Avenue South in 1910. He left shortly afterwards for Butte, Montana, where he opened a jewelry store and eventually became a dentist and owned a dental laboratory. Note the window on the left, where Brick has hung his own postcards.

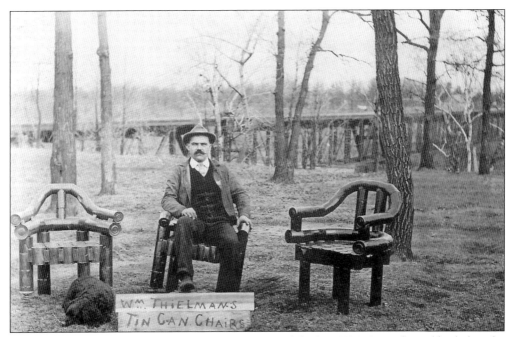

Here is William Thielman, who was born in 1869 and died in 1926. A confirmed bachelor, the professional tinsmith was also an accomplished shooter and hunter. Thielman is pictured here with models of his classic tin can chairs. The setting is Empire Park; the railroad bridge runs directly behind him. His shop was at 403 St. Germain Street.

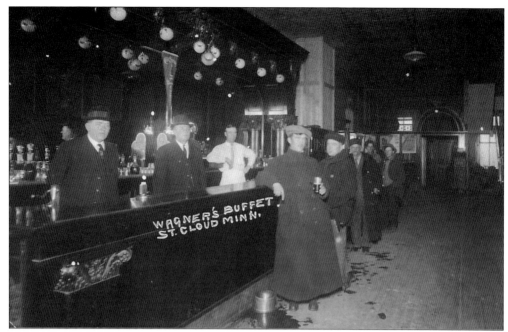

In 1914, the Rendezvous Saloon sat at 715 St. Germain Street. John P. Wagner, who also owned Wagner's Restaurant on the second floor, owned the watering hole. The building seems to have always housed saloons; today, it is the home of McRudy's Pub. Unfortunately McRudy's can't match Wagner's 1914 prices, which included a complete Thanksgiving dinner for only 25¢.

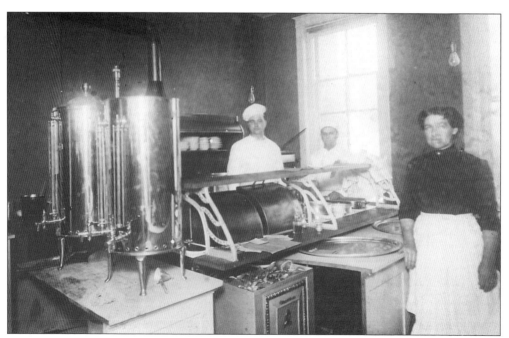

The kitchen staff here seems to have just passed inspection and looks ready to serve Wagner's customers.

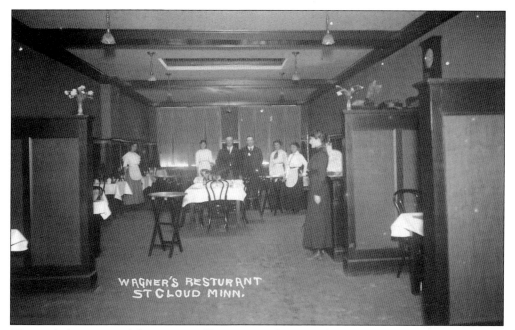

Wagner's hostess and her waitstaff are properly attired, inspected, and ready for the evening rush.

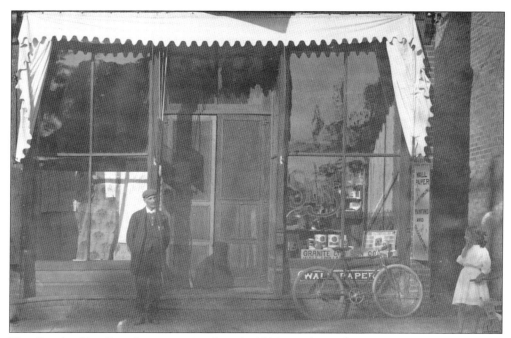

The Granite City Sign Company, seen here in 1908, was located at 721 St. Germain Street. E. W. Tenny was the manager, and they manufactured all types of signs.

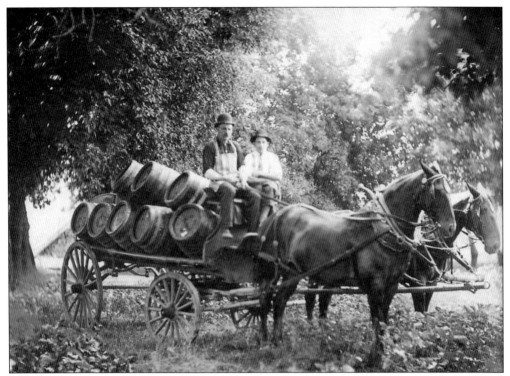

The inscription on this postcard declares that the photograph was taken in St. Cloud, but it does not provide the name of the brewery these men represent. When this picture was taken in 1908, the two largest breweries in town were the Preiss and Wimmer Brewing Company and the Udermann Brewery (formerly the Empire Brewery).

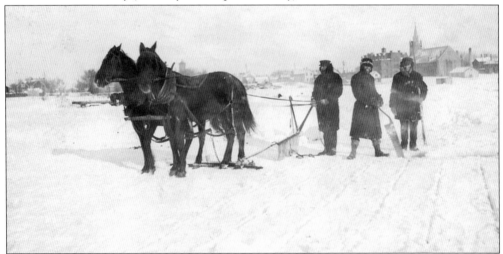

This is a view of ice cutting on Lake George about 100 years ago. Ice was also cut for St. Cloud on the Mississippi River and at Pleasant Lake. It was stored in large double-walled icehouses and covered with sawdust and sometimes straw. The smaller blocks of ice were then washed and delivered to homes and some businesses. Iceboxes were two-door cabinets, with ice in the top section and food in the bottom. Modern refrigeration killed the natural ice-harvesting business.

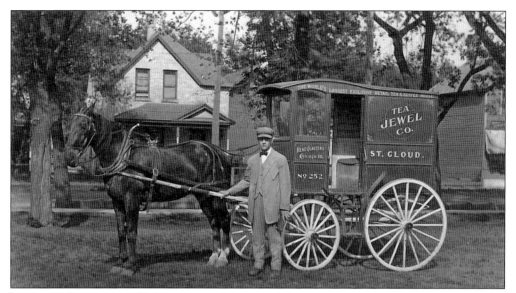

Preparing for a parade, the Jewel Tea Company man is parked in front of the home of midwife Magdalena Appert at 106 Ninth Avenue North. The building in back of the wagon was the Ninth Avenue Shoe Store. Jewel Tea was one of many selling systems such as Watkins Products and Raleigh that brought their business directly to customers by demonstrating, selling, and then delivering their products.

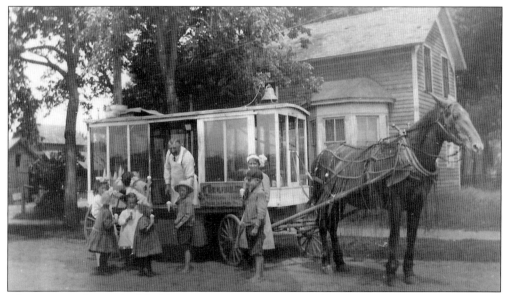

Clinton Spicer's wonderful old popcorn wagon is pictured here at the side of his home at 401 Twenty-First Avenue North in St. Cloud. The wagon's main feature, and children's favorite, was "Chums, a popcorn confection with a prize in every pack," as the sign states. It sounds like an early rendition of Cracker Jacks, which had first been introduced over in Chicago in 1908. Clinton ran the popcorn wagon from 1909 until his death in 1916.

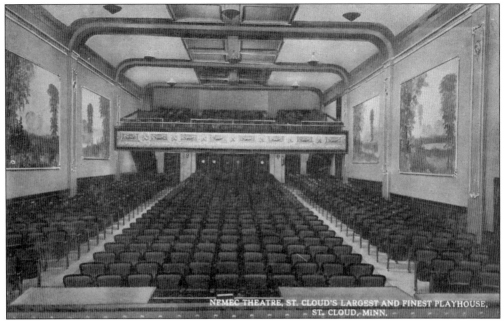

This theatre, located on the north side of St. Germain Street in the 400 block, opened in 1913 as the Starland Theatre. Built by Frank E. Nemec, it could seat 900 people. The theater operated under several other names over the years: Nemec, United Capitol, Peoples, Grand, and the Hays. It was demolished in 1977 to build the St. Cloud Public Library.

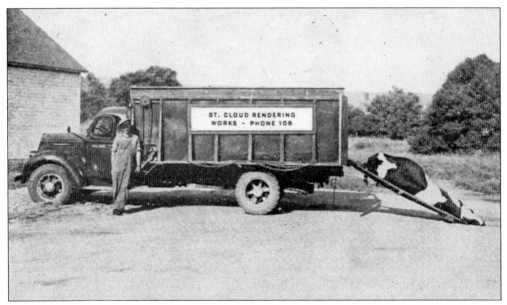

Here is an advertising card for the St. Cloud Rendering Works, on the back of which the outfit promises that it will remove dead or disabled stock (with the hides on) promptly and free of charge. The rest of the card reads, "Will call for one hog or more. Save this card for a free gift when we call."

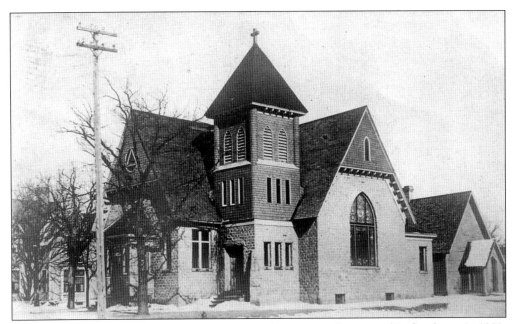

St. John's Episcopal Church was formed in 1856. The congregation erected its first home in 1858, which was the first church building in St. Cloud. In 1892, it was replaced by a granite-veneer block church, which stood for many years. The old church was pulled behind the newer church.

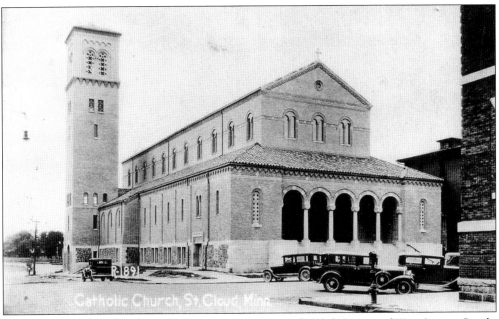

St. Mary's Catholic Church sits on the northwest corner of Eighth Street and First Avenue South. After the old church on St. Germain Street burned on August 25, 1920, planning and work started almost immediately on a new church. Leaders decided to build the new structure facing east on Eighth, as the old location was too valuable. A basement church was built in 1921, and the upper structure was completed in 1931.

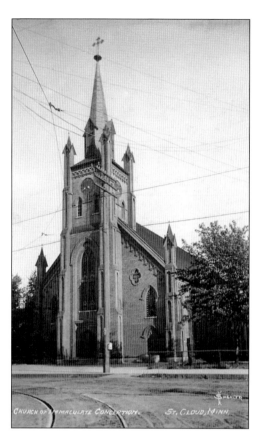

The German Catholic Church was built in 1865 and sat on St. Germain Street and Ninth Avenue North until it burned in 1920. Note how the streetcar turns right in front of the church and heads north. The card below shows the church just after it burst into flames.

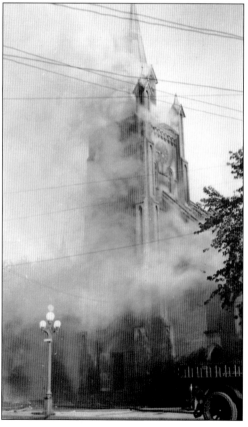

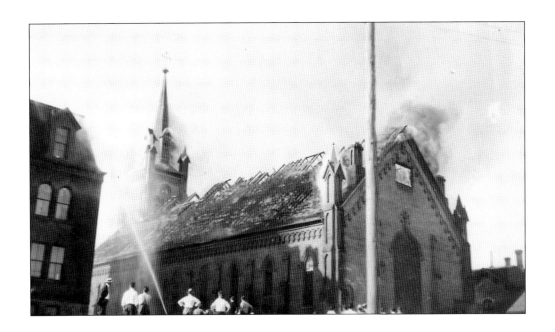

In the card above, the fire department valiantly sprays the roof and walls of the St. Mary's School to keep it from burning. They succeeded in saving the school, but they were not so lucky with the church. In the image below, all that is left of the latter is a burned-out shell.

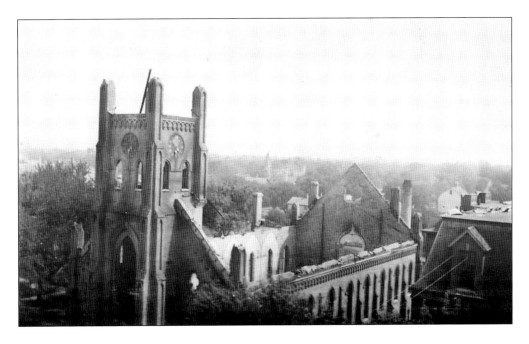

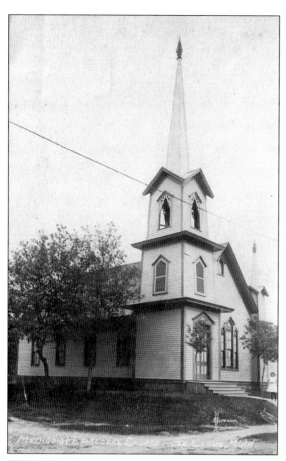

In 1873, the Methodists tore down the church they had built 10 years earlier on Fourth Avenue South and took the materials with them to build this church on the 300 block of Fifth Avenue South. For $300, the women of the congregation purchased the lot; it had formerly been the site of the "city lockup" and had also been used for St. Cloud's first courthouse.

In 1911, the Methodists again decided to build, and this was the result. They put a nice-sized gymnasium in the basement and pulled the old church behind the building and made it into the church's social hall.

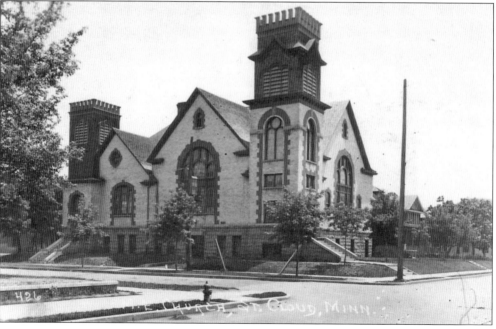

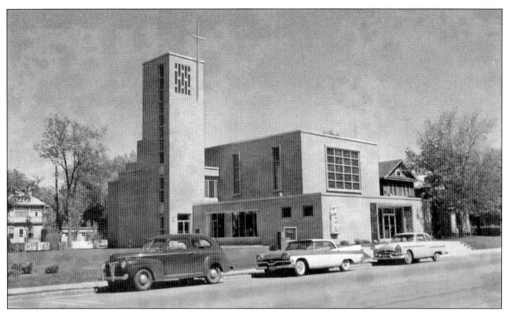

In 1954, the Methodists were building once again. First they constructed a sanctuary on the southern part of the lot before tearing down the old building. By 1960, they had completed the church's educational wing. This postcard shows the main sanctuary. In 2010, after over 150 years in this area, the Methodists were planning a new church in a new area.

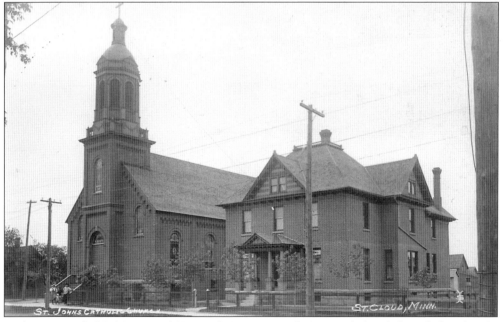

At the corner of Third Street and Sixteenth Avenue North sits St. John's Polish Catholic Church, which was built in 1901 of redbrick and granite at a cost of $9,000. The steeple was rebuilt of copper in 1927, as the original wood steeple had decayed and become dangerous. The Parish House was built in 1904. St. Cloud is now home to three Catholic churches catering to different ethnic groups: the German church (1865), the English-speaking church (1886), and the Polish church (1901).

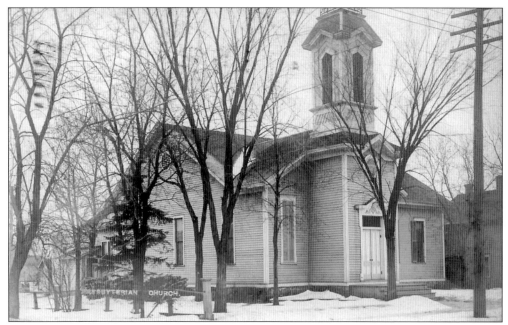

The Presbyterians organized in 1864 and built their church on Sixth Avenue in 1865. In 1876, they moved the church across the block to Fifth Avenue South near Second Street and added to it. They stayed there until 1917, when a new church was built at 373 Fourth Avenue South.

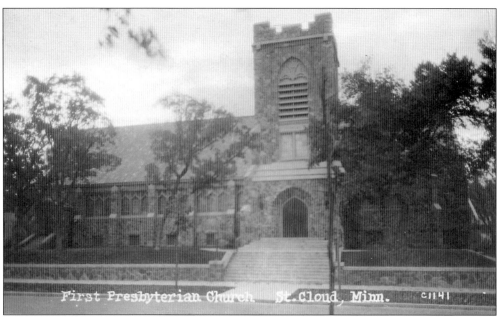

The Presbyterians built this church at 373 Fourth Avenue South as a memorial to Rev. E. V. Campbell and his wife, who had served both the church and the city from 1864 until their deaths in the 1920s. E. V. was a public school teacher during the week; he held his classes in the church.

The second Roman Catholic parish in St. Cloud, Holy Angels, was built in 1883 at a cost of $28,918. Located at the corner of Sixth Avenue North and Third Street, it was tailored to meet the needs of English-speaking Catholics. The church was the procathedral of the local diocese until 1937. On September 16, 1933, the building was struck by lightening and severely damaged. Workers installed a different roof, but the steeple was never again as tall.

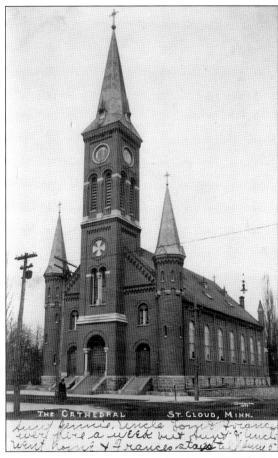

The Unitarians built this church in 1891 on the northwest corner of Fourth Avenue South and Second Street. In 1912, after a gift from Andrew Carnegie, a pipe organ was installed. When the congregation disbanded, the city bought the building, and it was used for short periods as a youth center and a historical museum.

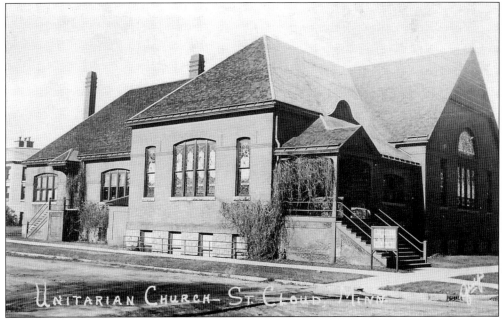

The First Baptist Church of St. Cloud started Christmas Day in 1855, laying claim as the oldest organized congregation in town. This building was constructed in 1886 at the corner of Second Street and Seventh Avenue South. By 1964, the lack of parking and crowded conditions caused the church to construct a new church building at 1230 Highway 23 Southeast. The last tenant in the building pictured here was the Model College of Hair Design, which erected a new structure on the property and demolished the old building in 2009.

In 1905, the Swedish Baptist Church was moved from 200 Wilson Avenue Northeast to 223 East St. Germain Street, and the entryway and steeple were added. In 1934, it became Calvary Baptist Church. In the early 1960s, Calvary moved to 1800 Roosevelt Road, and Raymond Benson started Benson Funeral Home in the church's old building. Benson later moved to a new structure on Twenty-Fifth Avenue South, and the Salvation Army took over the old church building.

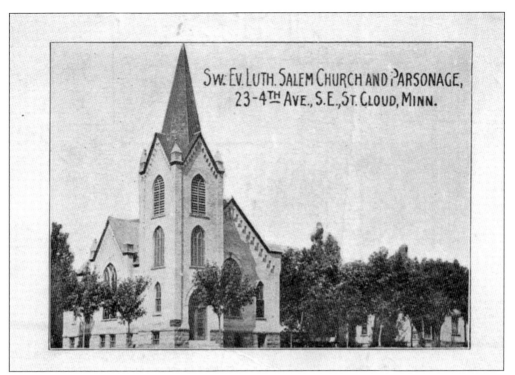

This is the Swedish Evangelical Lutheran Church at 23 Fourth Avenue Southeast, which later became Salem Lutheran. The original building was on Wilson Avenue in 1883, and in 1898, it moved to this address. In 1905, the Lutherans suffered a fire, but they rebuilt in 1906. They replaced the structure with a new building in 1956.

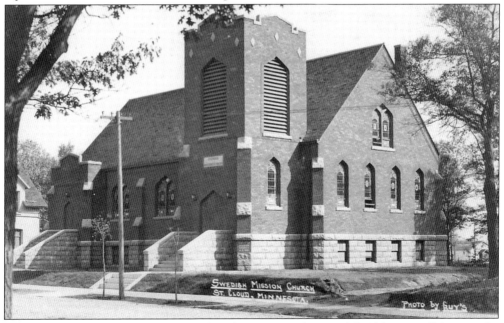

This was the Swedish Covenant Church, a very substantial building until it met the wrecking ball.

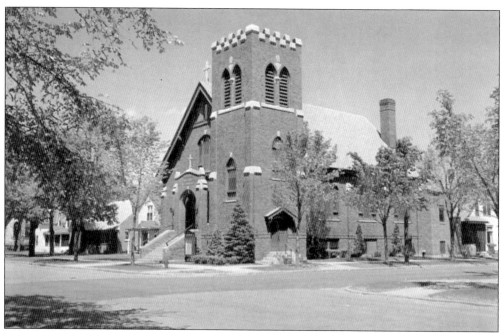

Holy Cross Lutheran Church originally sat at 430 Eighth Avenue South, but due to the a lack of parking, they have moved to 2555 Clearwater Road in St. Cloud.

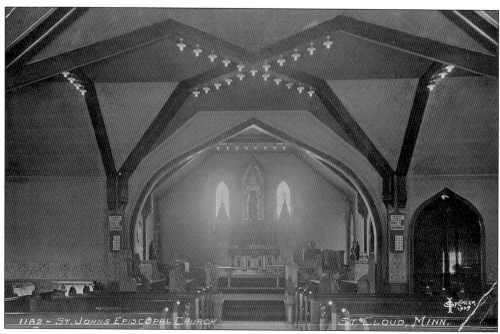

This is the interior of the St. John's Episcopal Church, built in 1892.

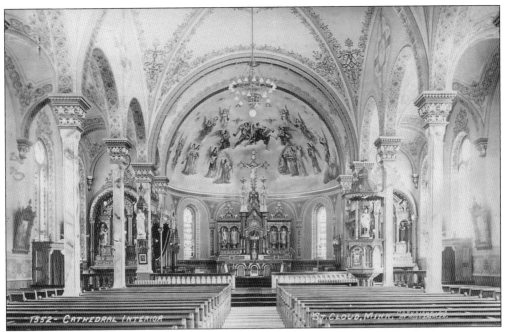

This postcard shows the beautiful interior of Holy Angels Pro-Cathedral. The decorating was done by John B. Martini, who had much experience in the decoration of churches in Europe, and his sons John and Peter. All of this art was destroyed when the cathedral was struck by lightning and burned in 1933.

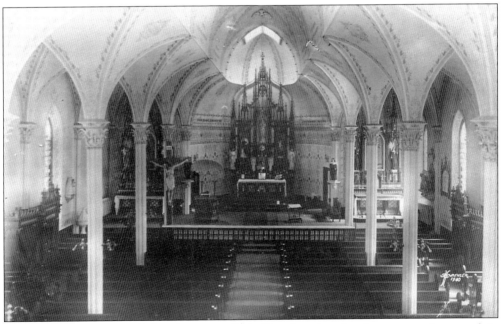

This is the interior of the German Catholic church, also known as Immaculate Conception Church.

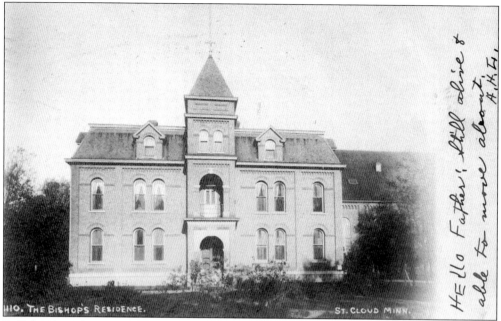

Built in 1890, this was originally a residence for St. Cloud's first Roman Catholic bishop, Otto Zardetti. He had wanted a home fit for a bishop, so he got a donation of 80,000 bricks from St. John's and levied a house tax on all the parishes of the diocese. The years took its toll on the building, and it became too dangerous to use and was demolished in the summer of 2009.

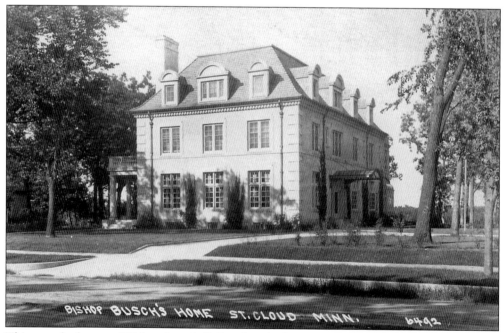

This was the home of Bishop Joseph F. Busch, which was located in the 200 block of Third Avenue South. It was built in 1916 at a cost of $45,000—$30,000 of which came from Busch's own mother, Anna Busch. Upon his death in 1953, the residence became the chancery of the Church of St. Cloud

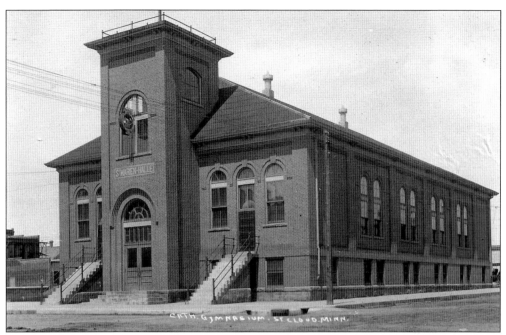

St. Marien Hall, or St. Mary's Hall, a Catholic gymnasium building, was located on the corner of Eighth Avenue and First Street South. All Catholic men between the ages of 16 and 40 were eligible for active membership. In 1916, the Institute was built around it. This became a real multipurpose building with classrooms, meeting rooms, a swimming pool, bowling alley, and a workout room.

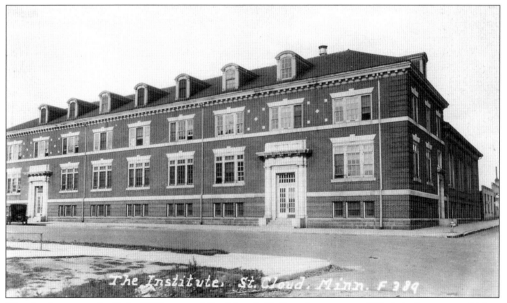

The Institute was built in 1917 around St. Mary's Hall at the corner of Eighth Avenue and First Street South. It was taken down in 1972, when the ring road was built. It was used as a temporary hospital during the 1918 flu pandemic, served as a temporary courthouse in 1922 and 1923 while the new courthouse was under construction, provided room for overflow classes at Cathedral School, and in 1937 became a temporary U.S. post office.

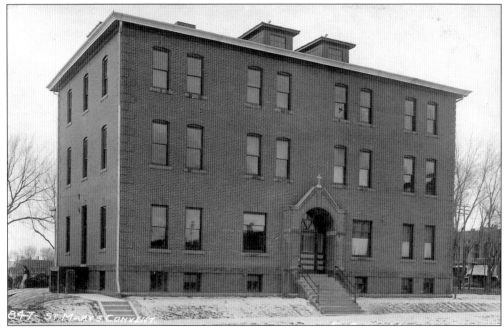

Located at 15 Eighth Avenue South, this was St. Mary's new convent in 1908 that was built to house Benedictine sisters, teachers, and building staff. In later years, the building became a rectory and parish offices.

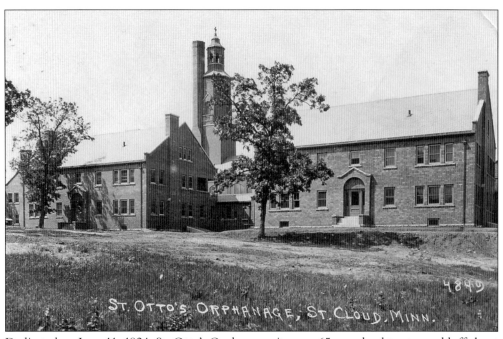

Dedicated on June 11, 1924, St. Otto's Orphanage sits on a 65-acre land tract on a bluff about 75 feet above the Mississippi River. The original population of 150 homeless orphans and a staff of 27 Franciscan sisters came from the orphanage in Little Falls.

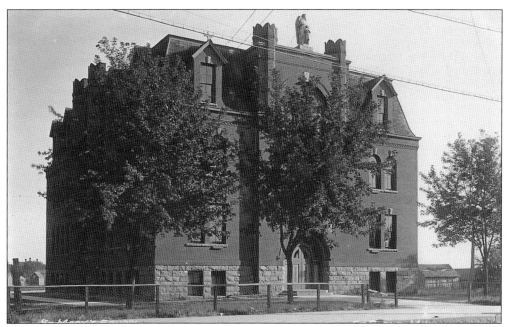

St. Mary's School, built in 1896, sat next to the German Catholic Church, which has been gone since the 1920s. It was necessary because of the increasing number of children and an outdated facility. The first and second floors had eight large classrooms, and the third floor had a very large auditorium.

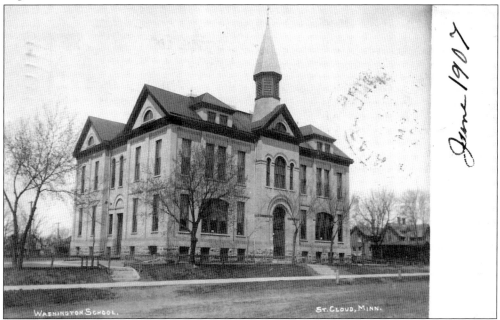

Here is the original Washington Elementary School, built in 1887. In 1949, ground was broken for the new Washington School on the same grounds just west of the original building. It opened in September of 1950. Amenities were slow in coming to the early schools. Electricity came to the school in 1889, and by 1893, Washington received city water, though at first it was undrinkable and only to be used in putting out fires. In 1911, the school was connected to the city sewer.

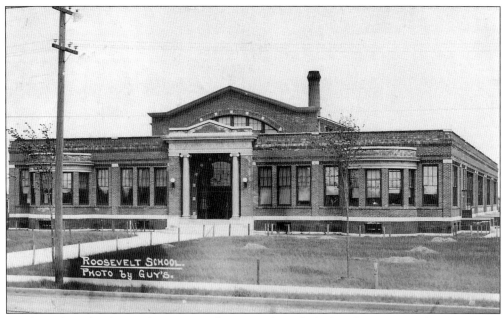

Work on this school started in 1919, and it was to be called Theodore Roosevelt School. The building wasn't ready for the start of the 1920 fall term, so temporary quarters were needed. School leaders rented the Motor Hotel, one of the Pandolfo buildings, so that they could hold classes. That year, two teachers and their 42 pupils made up what came to be called The Motor School.

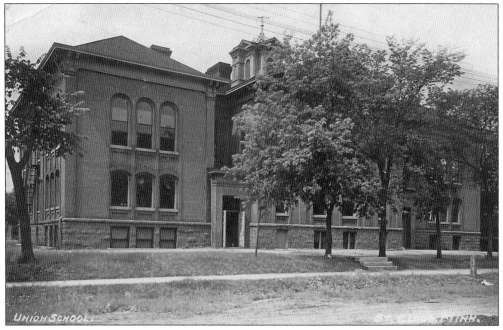

The Union School, at Fourth Avenue South and Second Street South, was built in 1896 at a cost of $17,000. Designed to accommodate 400 students, it is now the current site of city hall. This building was used as a high school until Technical High School was constructed in 1916, and then this became Central Junior High.

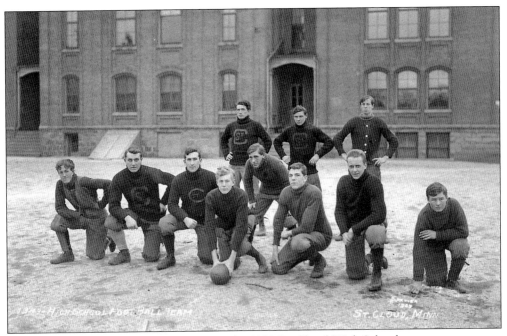

This professional-looking football team is the 1909 St. Cloud High School team.

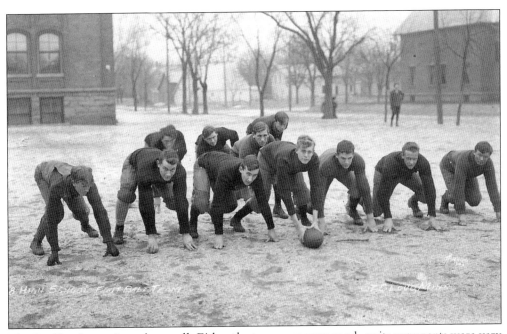

The St. Cloud team is ready to roll. Either the team was very good, or its opponents were very bad—on the back of the card, someone wrote about beating Royalton, 105-0.

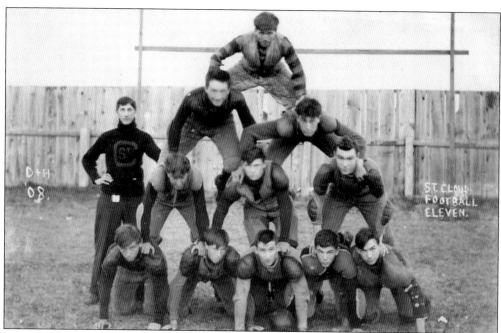
Here is the 1908 team demonstrating a peculiar new type of formation that was sure to confuse its opponents.

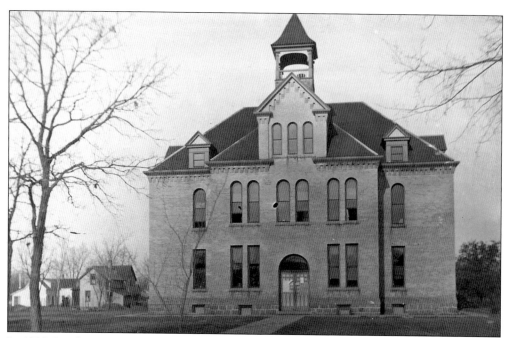
In 1889, bonds were issued to buy a site and to erect the first Lincoln School building in East St. Cloud. Bonds were again issued in 1914 to add a good-sized addition.

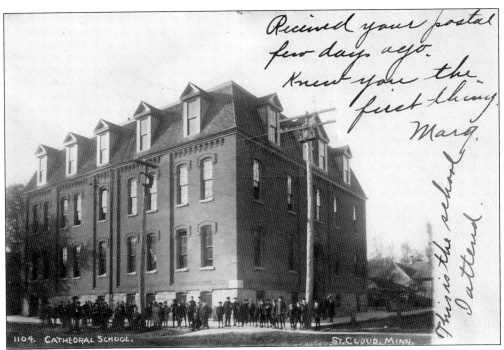

The Cathedral Grade School stood directly across Third Street from Holy Angels Church. The school opened in October 1887, and it was closed in the 1950s.

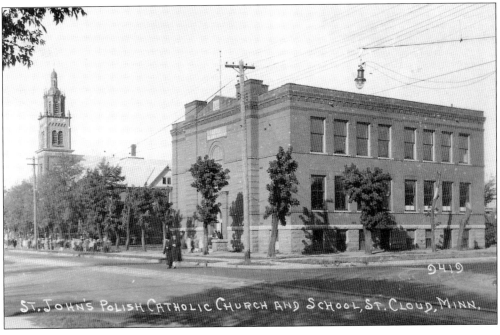

Here is the grade school for St. John's Catholic Church. The school was built in 1915 and served the children until 1973. It was then used for various parish activities and then finally demolished in the fall of 1992.

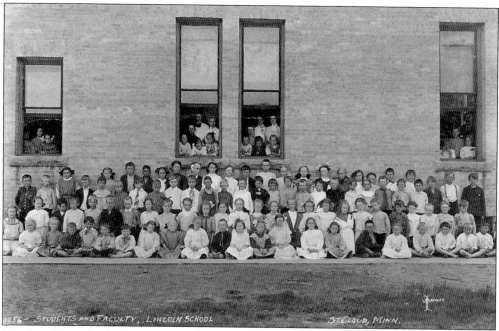

It is time for a school picture at Lincoln School on St. Cloud's greater east side.

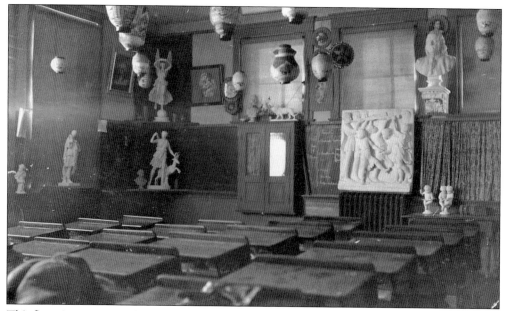

This fine vintage postcard provides a glimpse of the interior of a classroom at the Franklin School. In 1898, bonds were issued to put up the Franklin School on the site of the old Independent School between First and Second Streets North and Tenth and Eleventh Avenues North.

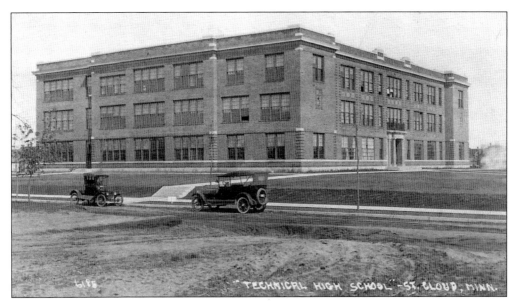

Technical High School, commonly known as "Tech," was built in 1915—1916 to replace the old Union School. The school's location caused a lot of controversy at the time, because the property was considered "way out in the country."

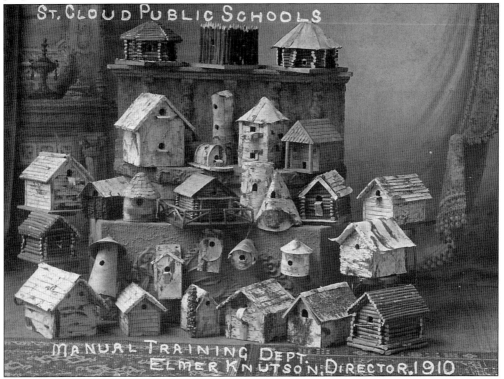

Elmer Knutson taught manual training in St. Cloud schools from 1906 to 1920 and won national recognition by originating the idea of building houses for birds. He then went to work for the American Association of Railroads in 1922 and ended up as manager of agricultural relations with railroads. He was a brother of Congressman Harold Knutson.

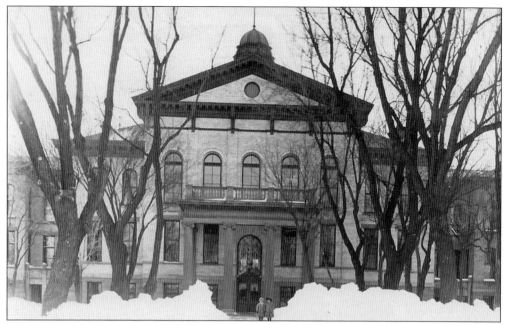

Old Main was the primary building for the St. Cloud Normal School. It was completed in 1874 and enlarged and remodeled many times. When Stewart Hall was built, Old Main was demolished. The Normal School became St. Cloud State Teachers College in 1921, St. Cloud State College in 1957, and St. Cloud State University in 1975.

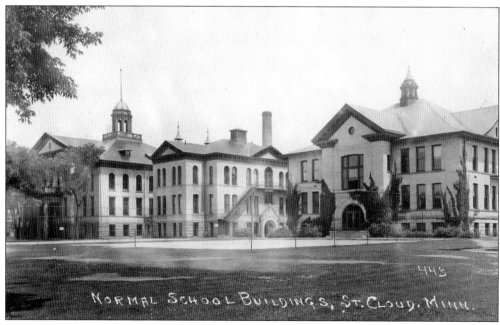

This is a very nice view of the buildings on the Normal School campus. From the left are Old Main Hall, the Library, and Riverview School.

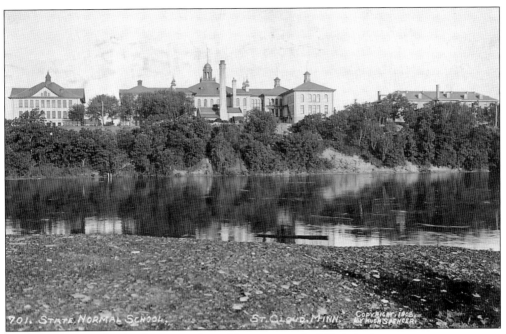

Here is the Normal School campus viewed from across the Mississippi.

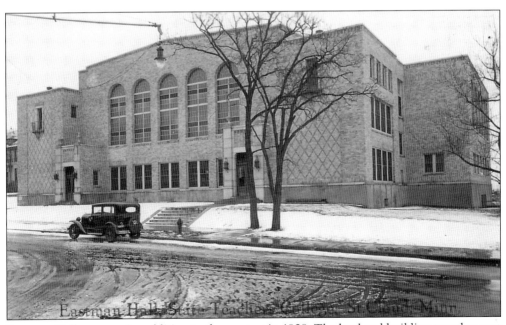

Eastman Hall was a major addition to the campus in 1929. The land and building together cost $225,000, but it was a great facility for athletic events, including intramural sports and even college dances.

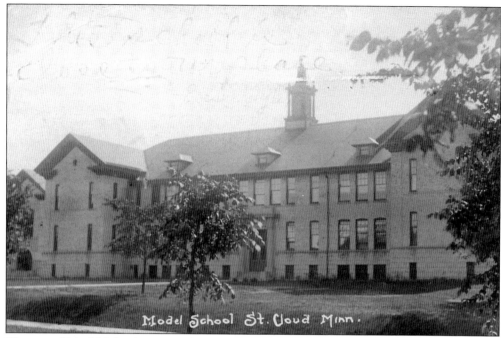

The second Model School was completed in 1913 at a cost of $60,000. Soon renamed Riverview, it was considered to be one of the finest laboratory schools for training teachers in the country. The 1906 first Model School was converted into a library.

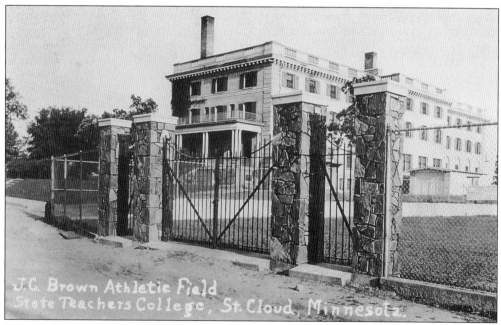

The new J. C. Brown Athletic Field was dedicated during the school's 1927 homecoming. The state legislature bought the land, and the school's alumni association paid for its development. The field was not quite ready for football yet, so the homecoming game was played at the Tech High School Field.

Normal School students demonstrate their physical fitness in this 1912 postcard by showing a great deal of strength and agility.

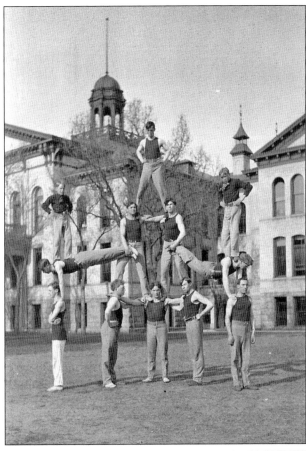

When World War I ended, this group of Normal School students celebrated with a peace parade.

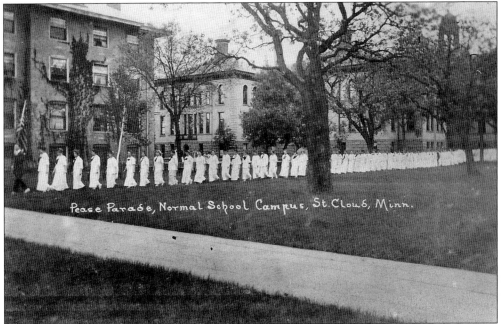

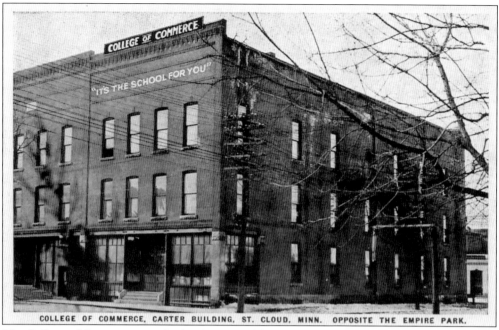

The College of Commerce was in the Carter Building at 501 First Street North. H. E. Biddinger ran the school from 1921 to 1925; its main competition was St. Cloud Business College.

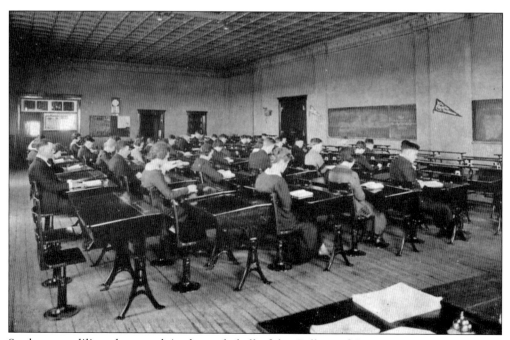

Students are diligently at work in the study hall of the College of Commerce.

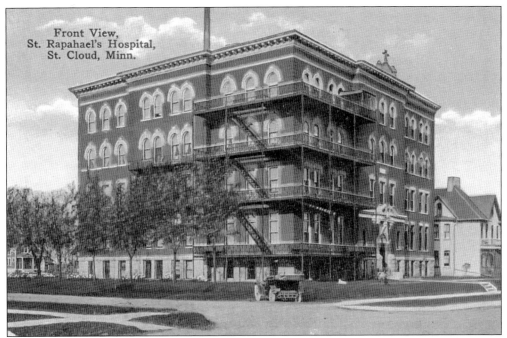

St. Raphael's Hospital was located at 511 Ninth Avenue North. This was St. Cloud's third hospital and was built in 1900. The first was St. Benedict's, the smaller structure to the right in this 1908 postcard. The second hospital was also called St. Raphael's, and was out near the reformatory in 1890. The distance from town was deemed such a drawback that the third hospital returned to 511 Ninth Avenue North in 1900. After a bad fire in 1905, its top floor was rebuilt, and the building received a different roofline. In the image below, nurses are enjoying a game of lawn tennis in the backyard.

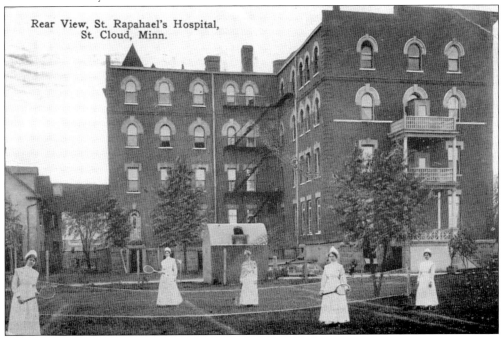

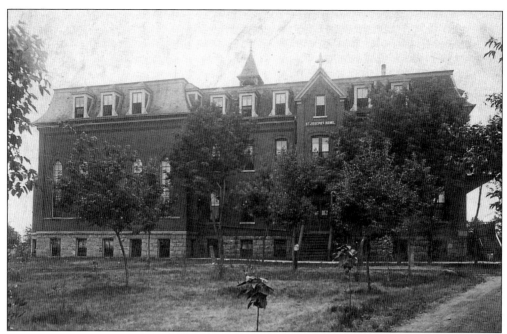

Constructed in 1890, this building near the reformatory was the original St. Raphael's Hospital. When they decided to move back to Ninth Avenue North, the pictured building became St. Joseph's Home for the Aged.

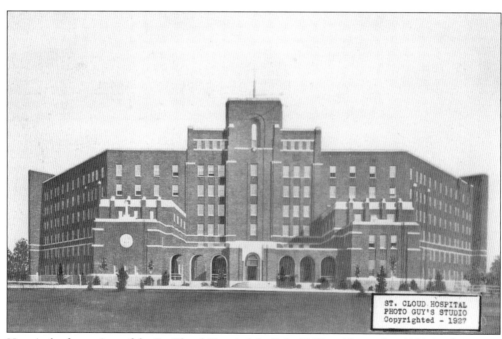

Here is the front view of the St. Cloud Hospital, built in 1927 and located at 1300 Sixth Avenue North. They are still expanding and remodeling this structure today and are one of St. Cloud's largest employers.

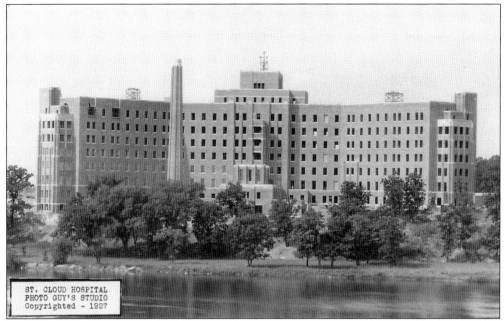

This shows workers in 1927 completing the St. Cloud Hospital by installing the windows. The large stack to the middle left was taken down in 2009 as part of a renovation project.

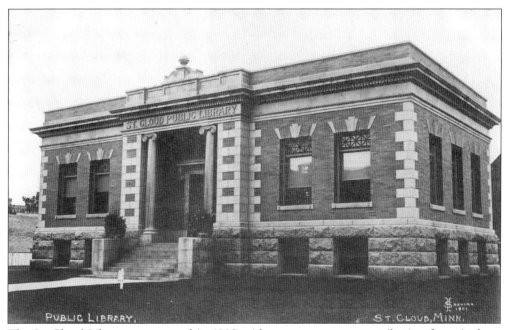

The St. Cloud Library was erected in 1902 with a very generous contribution from Andrew Carnegie. In the 1970s, despite conservationists' efforts to save it, the building was torn down for an office tower. The granite pillars on each side of the entrance were preserved, however, and can now be seen as part of the Stearns County Courthouse Plaza on Seventh Avenue North.

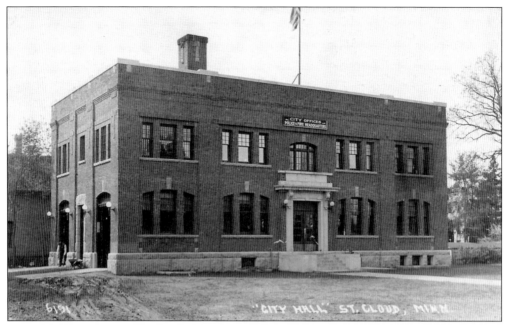

Demolished in May 1987 to make way for the St. Cloud Civic Center, this was the town's first multipurpose building. Built in 1917 and opened in January 1918, the St. Cloud City Hall included the police department, city justices, fire chief, and water department. Originally the plans for the building included housing Fire Station No. 2, but that had to be scaled back because of material shortages during World War I.

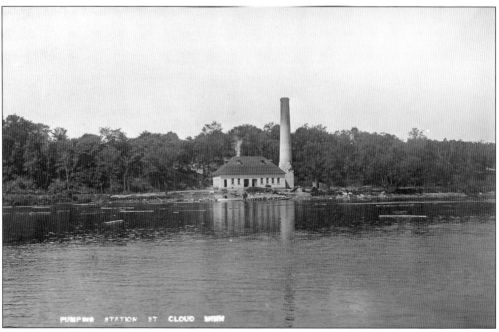

This pumping station was built in 1907 on the west shore of the Mississippi at Fifth Avenue North and Ninth Street North. An ultra-modern operation at the time, it was quite obsolete when the plant replacing it opened in 1957.

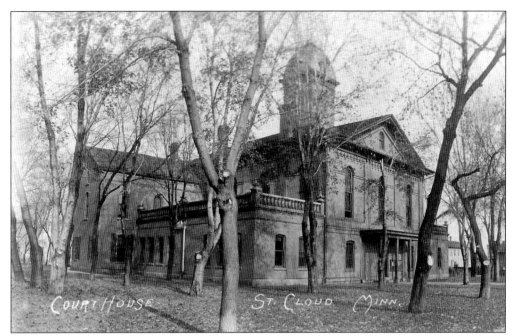

The main structure of the Stearns County Courthouse was built in 1863. Located at 725 Court House Square, the wings were added in 1896. It was demolished in 1920, and the new courthouse was erected on the same site. Business continued as usual during the construction; everything was moved over to the Institute, just a block and a half south on Eighth Avenue.

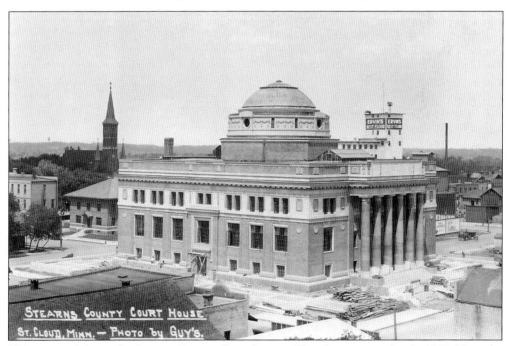

This postcard shows the Stearns County Courthouse still under construction in 1922. Note the two tall landmarks on either side of the dome. Erwin's Mill is now gone, and the tall spire on Holy Angels Church is now about half the height seen here due to a fire in 1933.

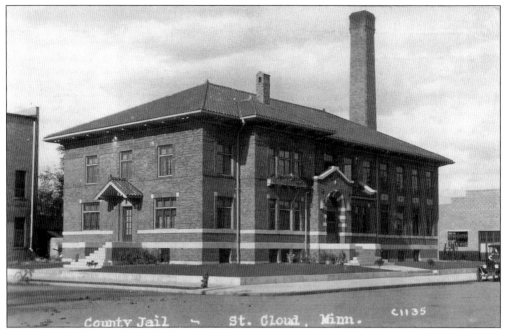

The Stearns County Jail was built in 1922 and was located across from the courthouse. It was originally designed so that the sheriff and his family could live on the second floor. As more space was needed, the second floor was converted to jail cells.

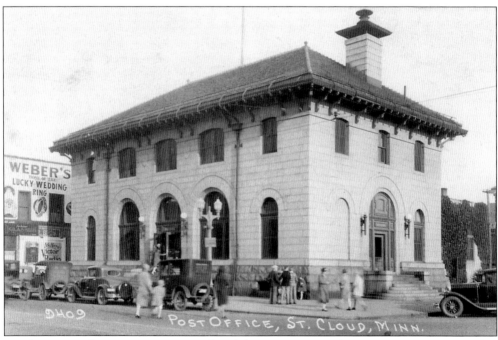

On the corner of St. Germain Street and Eighth Avenue South, this majestic granite post office was built in 1902. By 1936, it was no longer adequate, so St. Cloud bought it for use as a city hall. In 1937, it was moved four and a half blocks down the street. A new post office was built here, and it lasted until a larger one was constructed in 1965.

Three
PEOPLE AND OCCASIONS

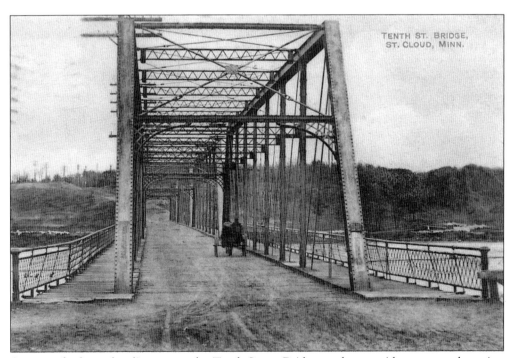

A cart and a horse heading across the Tenth Street Bridge to the east side appear to be going back into the past. Drivers had to hope that they didn't meet a car. Today's four-lane University Bridge overlooks the dam and is as different from the old bridge as today's jumbo airplanes are from the first Wright flyers. The 1890 bridge cost $81,876 to build; it was replaced in 1985 at a cost of $7.6 million.

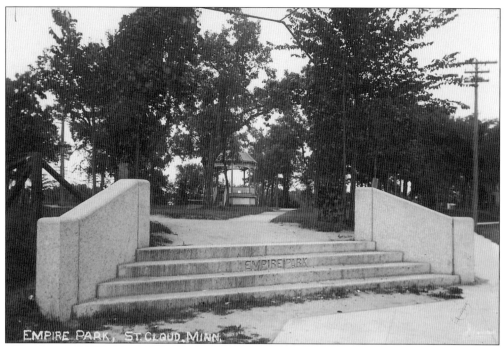

The entrance to Empire Park, seen here, was on the block between Fourth and Fifth Avenues and the north side of First Street North. On July 1, 1880, the park was purchased for the city by the city council for $1,200. It was named Empire Park after James Hill, known as "the Empire Builder."

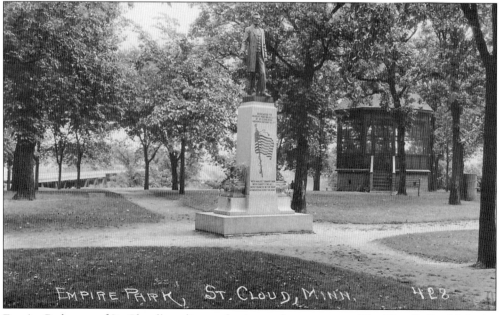

Empire Park, one of St. Cloud's earliest parks, is now home to one of St. Cloud's first high-rise apartment buildings, Empire Apartments. A remnant of the lot's days as a park is the statue of Abraham Lincoln, which was dedicated to McKelvy Post 134 of the Grand Army of the Republic on May 30, 1918. It was a gift to the city by the Lodges and Societies of St. Cloud.

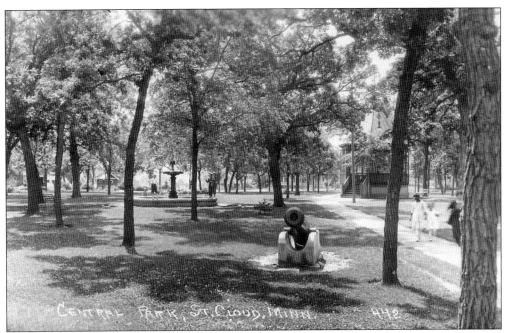

Central Park dates back to 1855, making it older than the city of St. Cloud itself. The cannon pointed towards the reader stood near the park's northeast corner. Removed during World War II during a scrap-iron salvage campaign, the cannon came from the Spanish battleship *Viscia*, which surrendered during the Spanish-American War.

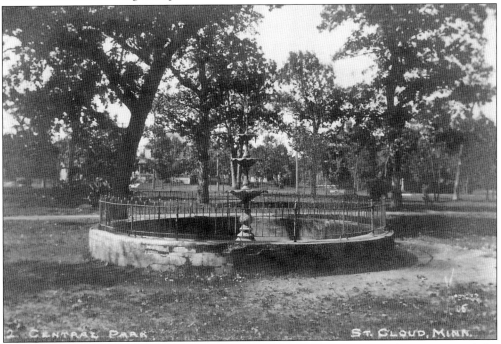

Central Park was so named because it was centrally located between Lake George and the Mississippi River. It was renamed Barden Park in 1938 in honor of Charles Barden, the park superintendent from 1910 to 1926.

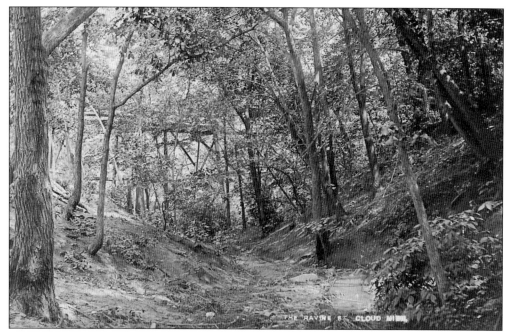

This 1908 postcard gives an idea how deep the ravines were. Look about two-thirds of the way up and one can see the bridge through the branches. This ravine, which ran from Lake George to the Mississippi River, had several footbridges along the way, the most popular of which were the ones on Third and Fourth Avenues.

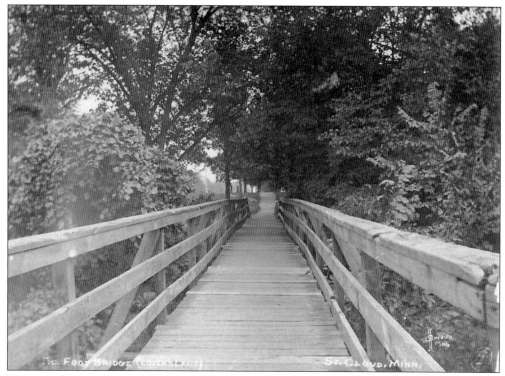

The straight Third Avenue footbridge, shown here, was known as Lover's Lane.

St. Cloudians called the Fourth Avenue footbridge Lover's Lane as well. Note the curve in this bridge. Straight ahead is the Pattison house, and to the left is the Foley-Bohmer house.

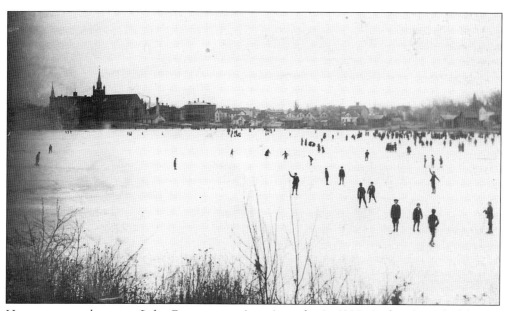

Here are many skaters on Lake George on a nice winter day in 1908. At that time, the lake ran all of the way from behind St. Mary's almost to Seventh Street South.

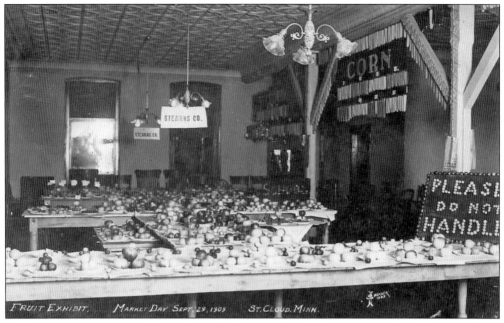

The fruit exhibit took place during Market Day on September 29, 1909. It was held in the Commercial Club Rooms on the second floor of the Carter Building. This was a forerunner of today's St. Cloud Civic Center.

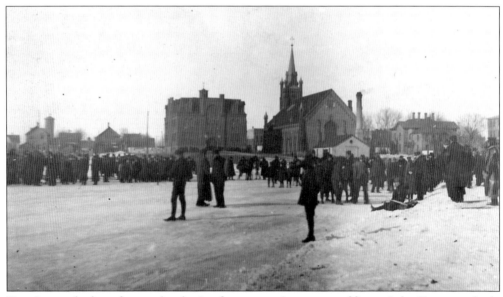

Here is an early shot of a crowd gathering for an event in a corner of frozen Lake George; nobody has ice skates on. St. Mary's School and Immaculate Conception Church are in the background. The card was never mailed, so there is no message on the back.

Here are Queen Zephra and the Red Hussars. This souvenir postcard came from a musical performance at the Davidson Opera House in May 1912. It was under the auspices of the Catholic Young Men's Association (CYMA), St. Cloud, Minnesota. This was a local cast. The Davidson Opera House was on the 200 block of Fifth Avenue South.

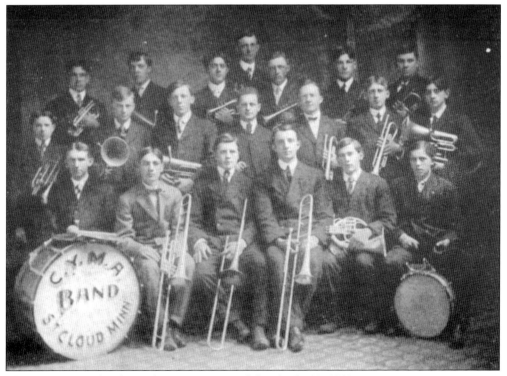

The CYMA Band is shown here on a postcard dated July 21, 1910.

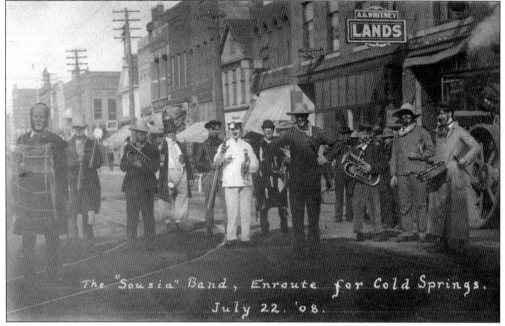

This merry band calls itself the "Sousia" band. Dressed in special clothing, the group is headed for Cold Spring on July 22, 1908—and undoubtedly destined to have fun along the way.

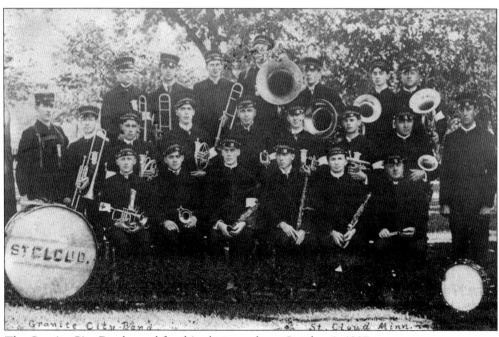

The Granite City Band posed for this photograph on October 1, 1907.

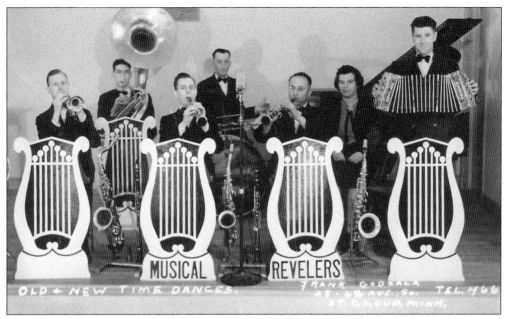

Here are the Musical Revelers, a group that specialized in old-time and modern dances. From left to right, the Revelers are Jack Ludtke, unknown, Henry Strobel, Percy Parsons, Frank Godzala, Minnie Blaske, and Jack Kipka.

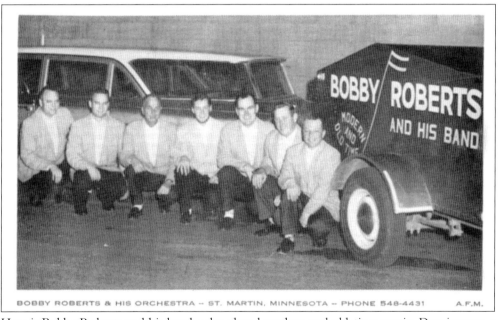

Here is Bobby Roberts and his band, who played modern and old-time music. Dancing was a big part of socializing in this area.

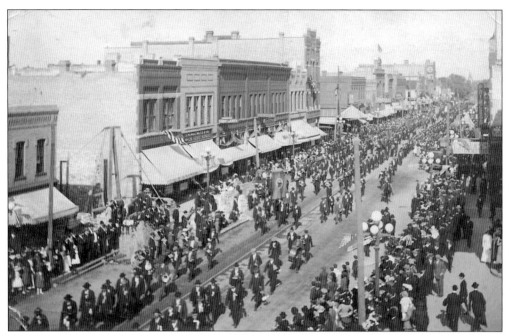

On Monday, June 13, 1913, a parade started at 7:30 p.m. It was the 13th annual convention of the Minnesota State Federation of Labor, which played host to 275 registered delegates.

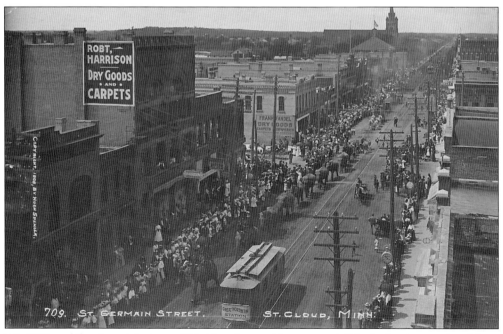

It is 1908, and the circus is in town. What is a circus without a parade? And what is a parade without elephants? Here are 10 of them, stretching from Harrison's Department Store to Fandel's.

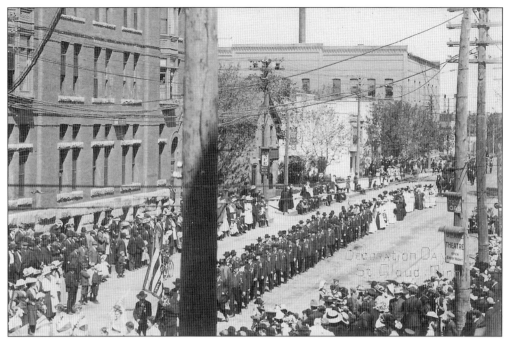

It is Decoration Day, 1910, and the parade is just starting off on Fifth Avenue North. In the forefront is the James McKelvey Post 134 of the Grand Army of the Republic, and the latter part of the group is the Women's Relief Corps, the auxiliary of the GAR.

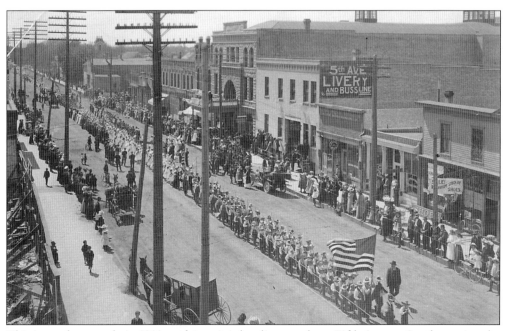

This is another parade in 1910, and now it is heading north on Fifth Avenue South, passing the 100 block. This provides a nice view of the Davidson Opera House across the street, before the devastating fire, showing people standing out on the balcony and the full roofline.

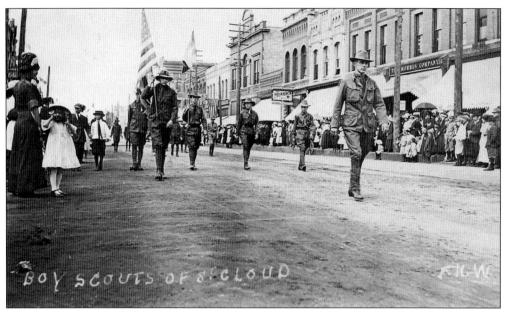

This parade in 1911 is led by Boy Scout leaders who are marching east on the 600 block of St. Germain Street. Since the Boy Scouts were organized in 1910, this verifies a very early start for them in St. Cloud.

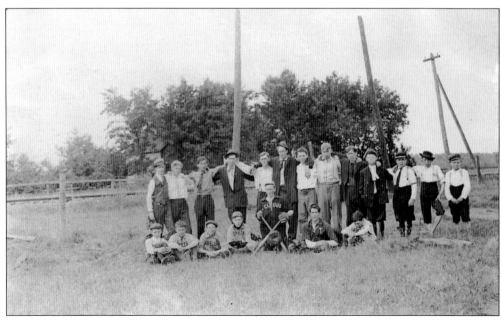

Here is the youth baseball team sponsored by David Ables of Ables Department Store. The store was located in what is now the Radio City Music Mall.

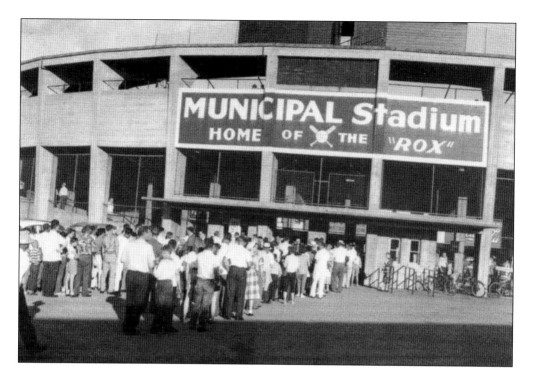

The Municipal Stadium, "Home of the Rox," sat just off of Division Street on the south side between Byerly's and the Miller Shopping Center. It was very popular in the 1940s and 1950s, before the rise of television. The above postcard shows the front of the stadium and the ticket line, and the postcard below shows the stadium from the outfield. Obviously there was a capacity crowd that night.

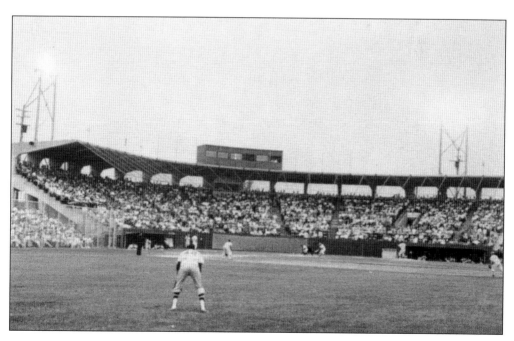

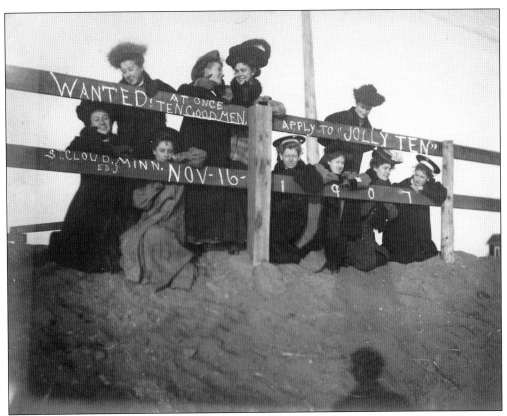

The group of young women pictured above, with faith in the power of advertising, placed this sign looking for 10 good men. Applications were to the "Jolly Ten," and the date was November 16, 1907. The response was overwhelming, and the women arranged to interview prospective "good men" in the park down by the dam. Pictured below is the agility phase, shown by the applicant's leap-frogging ability.

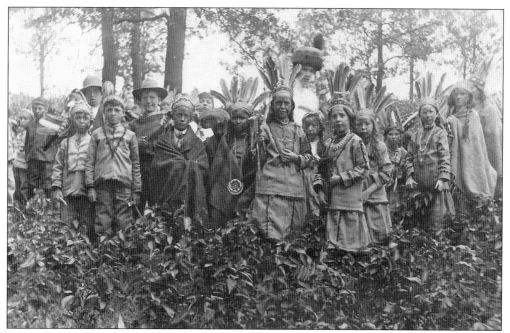

In this photograph are Lincoln School students dressed in Native American garb for their Fall Pageant. A lot of effort went into making the costumes.

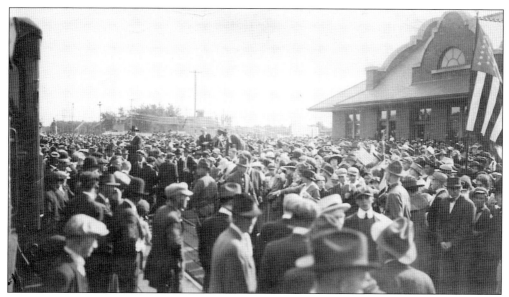

This large crowd at the Northern Pacific Depot on the east side was there to see the first selected boys off for World War I. This was on a Friday in September 1917.

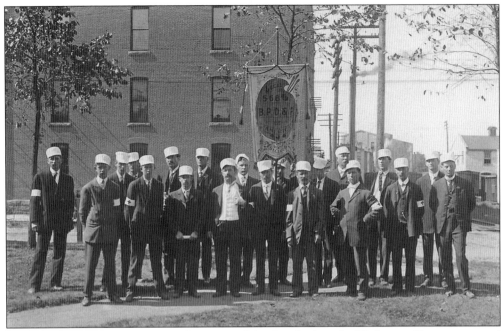

These are the officers and state directors of the Brotherhood of Painters, Decorators, and Paperhangers, who were in town for the state convention in 1913.

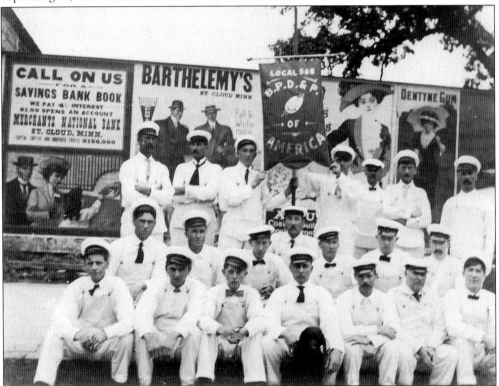

This is St. Cloud's own Local No. 568 of the Brotherhood of Painters, Decorators, and Paperhangers all dressed in summer whites for a 1910 event.

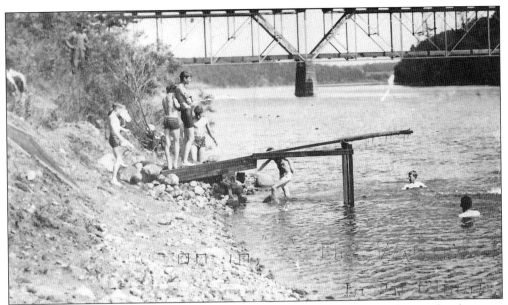

Swimmers enjoy the cool waters of the Mississippi in 1910. This photograph was taken between the St. Germain Bridge and the railroad bridge and faces north.

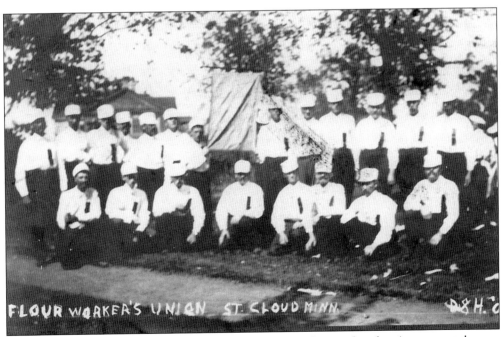

This is the Flour Workers Union. The back of the postcard states that the picture was taken on Labor Day, 1908, and that the picture is poor because the sun was bright and in everyone's eyes.

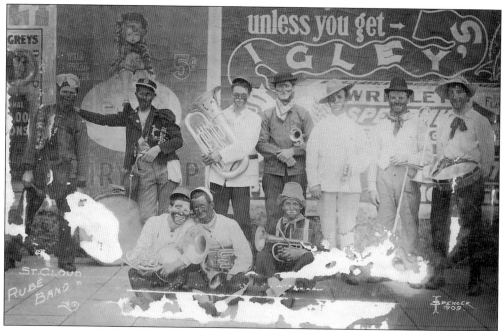

Here is the Rube Band, and the picture was taken on the stage of the Davidson Opera House in 1909. The postcard has some damage, but it is a classic photograph with the period backdrop and all of the early costumes.

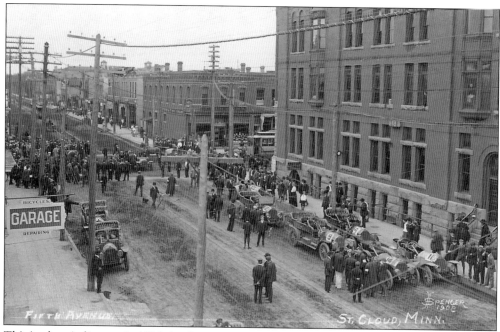

This is a hospitality run in 1908 that has stopped on Fifth Avenue by the side of the First National Bank. Look closely in the middle and it is clear that the festivities are holding up two streetcars and two horse-and-buggy rigs.

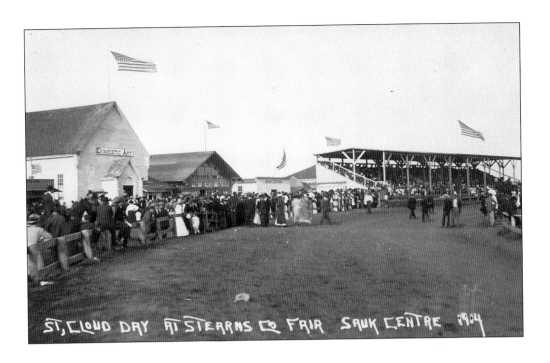

This is St. Cloud Day at the 1914 Stearns County Fair in Sauk Centre. Sauk Centre lies 45 miles northwest of St. Cloud. Below, it is now the Fourth of July and the fairgrounds enjoy another good crowd. A baseball game is underway in the center field.

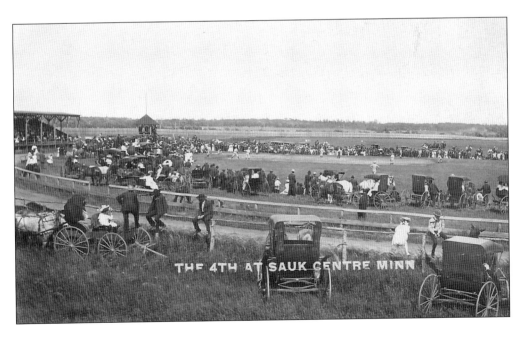

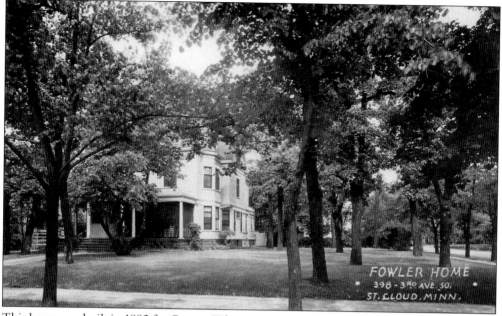

This home was built in 1892 for George Tileston, proprietor of the Tileston Milling Company, at a cost of $5,200. The 14-room house has a spacious 7,144 square feet. After Tileston lost his life at a young age, the home saw several owners. The Acacia fraternity owns it now.

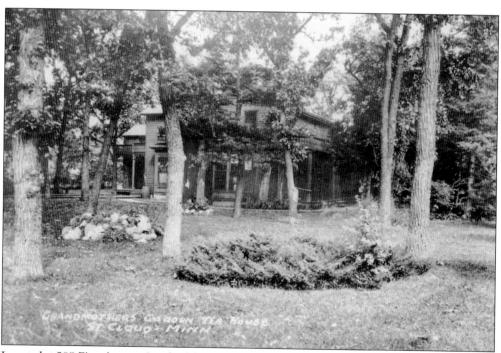

Located at 509 First Avenue South, this was originally the home of H. Z. Mitchell. Built in 1857, it was the oldest dwelling in St. Cloud when it was demolished for a parking lot for St. Cloud State College in 1957. From 1922 to 1934, the building was a restaurant known as Grandmother's Garden, which was run by Ruth Mitchell, granddaughter of H. Z. Mitchell.

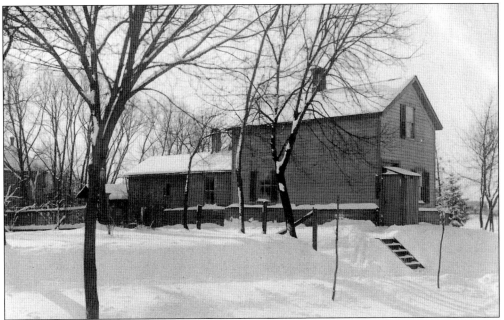

Sitting on the hill above Lake George from the early 1870s until 1912, at 802 Second Street South, was the home of George Stacy Spencer, a prominent druggist and St. Cloud citizen. Hugh Spencer was born here on July 19, 1887. He polished his skills in photography by capturing local scenes on postcards from 1906 to 1912. He then went to Connecticut, where he developed renown as an artist, illustrator, photographer, and woodcarver.

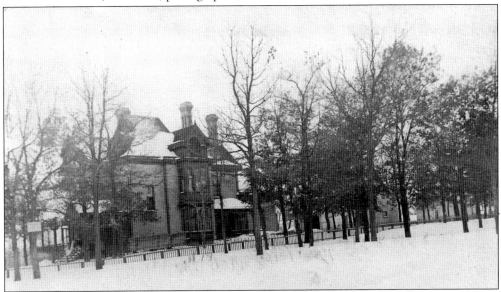

Joseph Wilson owned this home, built in 1888 and located at 123 Second Street Southeast, on the east bank of the Mississippi River. He was known as "the Father of East St. Cloud" and was a brother of John Wilson, known as "the Father of St. Cloud." At one time, Joseph was the largest holder of real estate in town and was the main promoter of the city's east side. When the Benton County Courthouse in Sauk Rapids was destroyed by the cyclone of 1886, Joseph offered to build and donate a new courthouse to the county in East St. Cloud.

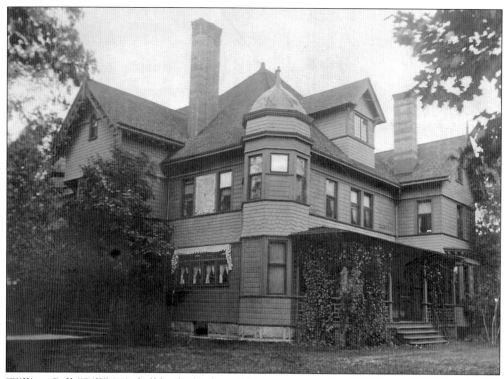

William Bell "Bill" Mitchell built this beautiful home located at 508 First Avenue South. Bill worked for his aunt, Jane Grey Swisshelm, on her newspaper, the *St. Cloud Democrat*. When Swisshelm returned to the East, Mitchell, at age 20, bought the paper. He enlarged it and renamed it the *St. Cloud Journal*. Then he bought the *St. Cloud Press* and combined the two publications to form the *Journal-Press*, the forerunner of the *St. Cloud Times*. He also authored the very comprehensive *History of Stearns County*, published in two volumes in 1915. The home was razed in 1938, and in 1957 a new dormitory, Mitchell Hall, was erected on the property.

This classic St. Cloud yellow brick home was located at 723 East St. Germain Street in 1908. The addresses were revamped in 1925–1930, and the address became 647 East St. Germain Street. It was the solid home of Edwin and Myra Harland and stood for more than 100 years before it was replaced by a parking lot.

From 1908 to 1912, this home at 701 Fifth Avenue South was the residence of Simeon A. and Mary G. Jones. Jones was a partner with his brother Marshall Jones in the Monumental Granite Works. The home still looks nice, and its residents can easily walk across the street to enjoy band concerts in Barden Park.

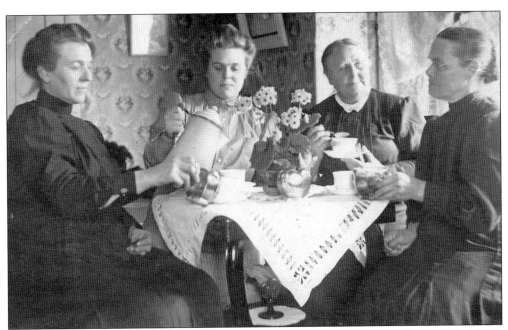

All that is known about these women having a rollicking good time at a coffee party in March 1911 is that they are identified on the back of the card as Mrs. Halleckson, her daughter, Mrs. Jack Hartmann, and Mrs. Birtils. The postcard was sent to Halleckson's son Willie in Chester, Iowa.

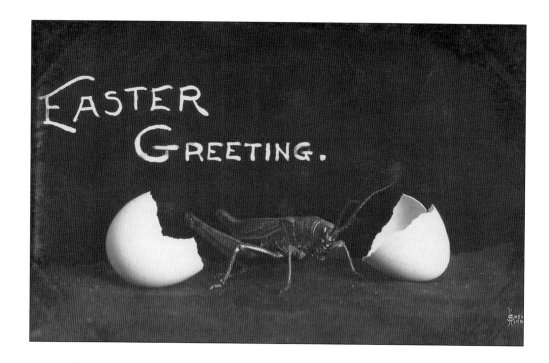

Here are very rare examples of early humorous postcards composed and shot as Real Photos. The Easter greeting contains a real grasshopper, and the April Fool's Day card has a hand-carved jester. Most of the early humorous cards were artist-drawn, color printed cards.

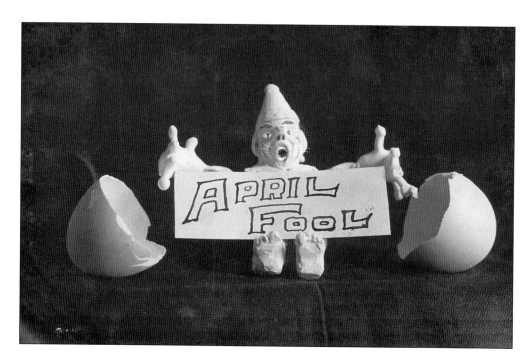

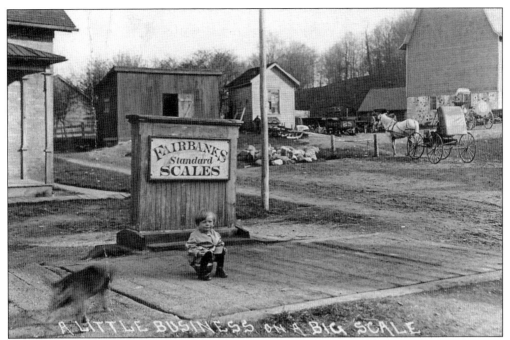

This type of Real Photo humor card involves a primitive sort of Photoshopping. The artist would take an actual photograph, such as this early farm scene, and then superimpose something into the picture. A small-town street, for instance, might receive a streetcar. Here a little guy on a scale has been superimposed onto a natural farm scene, with the title, "A little business on a big scale."

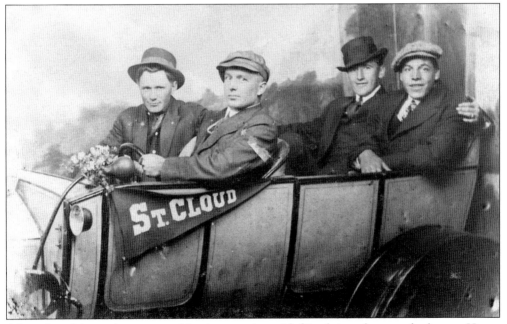

After a fun night on the town, nothing beats posing with friends in a photographer's prop. Henry Foehrenbacher is the fellow sitting in the right rear seat.

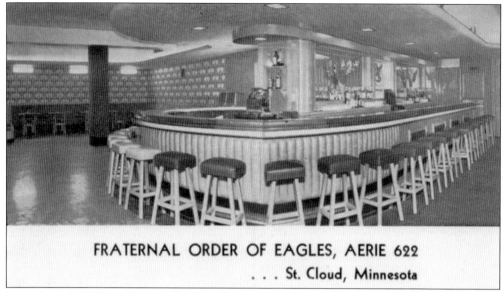

John Coates's old livery barn made a good place to put the Eagles Club in the 400 block of First Street South. Then the Ring Road was tried and lots of changes came about. The Eagles Club built new club rooms just off Highway 15 on Eighth Street North.

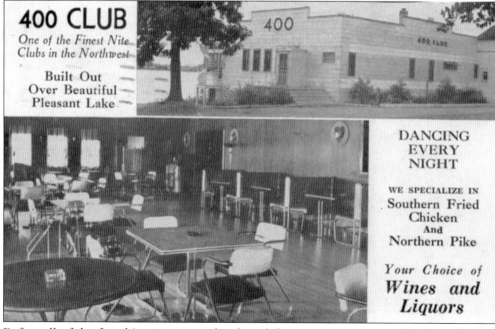

Before all of the franchises came out, local steak houses were very popular. As a form of advertisement, they would make postcards available to patrons who wanted to send messages. The club would pay the postage.

Another type of advertising card made use of comic characters and such gimmicks as a calendar, which made people look forward to the next month's card. This card seems to be aimed at the younger crowd.

Another collectible category is the "pennant" card, usually done in the local majority language. They are always printed cards, and the pennants are multicolored felt.

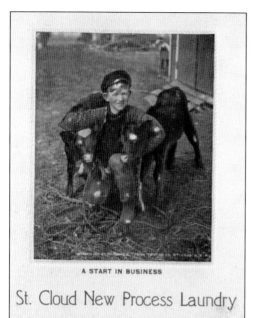

Here is an advertising card using a real photograph for the "catcher" portion. This postcard was created in 1906 to promote a new laundry and dry-cleaning firm.

This advertising card uses an appealing artist-drawn picture with a fixed message on the front. On the back, messages would rotate to appeal to different audiences.

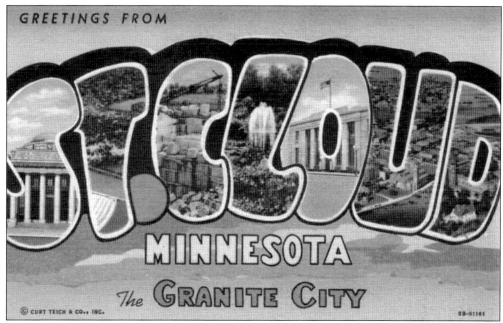

This is a large-letter greeting card that was made very popular by Curt Teich and Company, Inc. Each letter tells of a place of interest. In this example of St. Cloud are the county courthouse, an aerial view of college, the granite industry, the rock garden in Munsinger Park, the federal building, an aerial shot of downtown, and an aerial view of the reformatory.

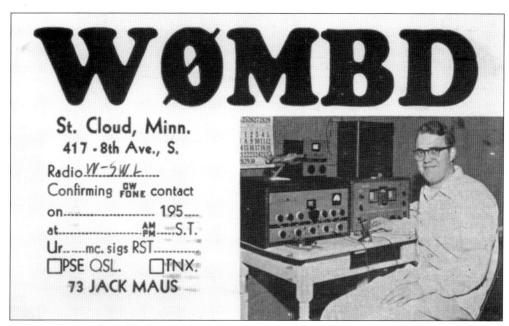

Here is a postcard used by ham-radio operators to confirm their contact with the radio. This is another category of collectible.

125

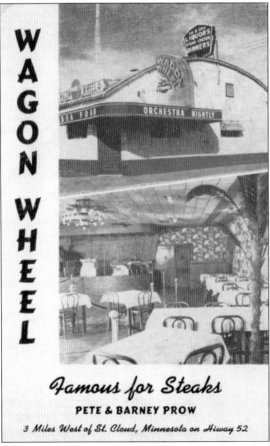

Here is an example of a linen view postcard. It is very colorful, and there is a different texture to the paper. Used mostly in the 1930s and 1940s, it was pretty much replaced by chromes, which featured a glossy, real-photograph look.

This is a combination of a black and white and a chrome advertising card. On the message side are the words, "You address it, and we will mail it."

Here a linen advertising card is promoting the Breen Hotel, which became the St. Cloud Hotel, which in turn became the Germain Hotel, which then became a highrise for seniors called the Germain Towers.

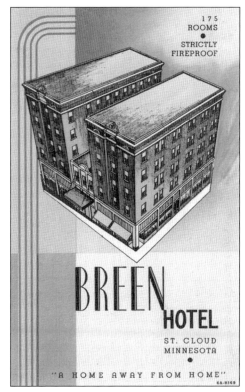

This is a very early Real Photo postcard of Myron H. Hall, who was born in St. Cloud on May 30, 1911. Hall was a professional photojournalist—the only staff photographer for the *St. Cloud Times* from 1937 to 1974. His gift to the Stearns History Museum of over 300,000 photographs is the backbone of their photograph collection. He came after the postcard era, but he started out on one.

www.arcadiapublishing.com

Discover books about the town where you grew up, the cities where your friends and families live, the town where your parents met, or even that retirement spot you've been dreaming about. Our Web site provides history lovers with exclusive deals, advanced notification about new titles, e-mail alerts of author events, and much more.

Arcadia Publishing, the leading local history publisher in the United States, is committed to making history accessible and meaningful through publishing books that celebrate and preserve the heritage of America's people and places. Consistent with our mission to preserve history on a local level, this book was printed in South Carolina on American-made paper and manufactured entirely in the United States.

This book carries the accredited Forest Stewardship Council (FSC) label and is printed on 100 percent FSC-certified paper. Products carrying the FSC label are independently certified to assure consumers that they come from forests that are managed to meet the social, economic, and ecological needs of present and future generations.

FSC
Mixed Sources
Product group from well-managed forests and other controlled sources

Cert no. SW-COC-001530
www.fsc.org
© 1996 Forest Stewardship Council

Find Your Place in History.